TRANSIENT SPACES

Untitled (Apartment)

Published on the occasion of the exhibition
Rachel Whiteread: Transient Spaces
Organized by Lisa Dennison with Craig Houser

Deutsche Guggenheim Berlin
October 27, 2001–January 13, 2002

Deutsche Bank &
Solomon R. Guggenheim Foundation

Rachel Whiteread: Transient Spaces
© 2001 The Solomon R. Guggenheim
Foundation, New York.
All rights reserved.
All works used by permission.

ISBN: 0-89207-252-0 (softcover)
ISBN: 0-8109-6934-3 (hardcover)

Guggenheim Museum Publications
1071 Fifth Avenue
New York, New York 10128

Deutsche Guggenheim Berlin
Unter den Linden 13–15
10117 Berlin

Hardcover edition distributed by
Harry N. Abrams
100 Fifth Avenue
New York, New York 10011

Photography: Gautier Deblonde
Design: 2 x 4, New York
Production: Jess Mackta, Cynthia Williamson
Editorial: Meghan Dailey, Elizabeth Franzen
Printed in Germany by GZD

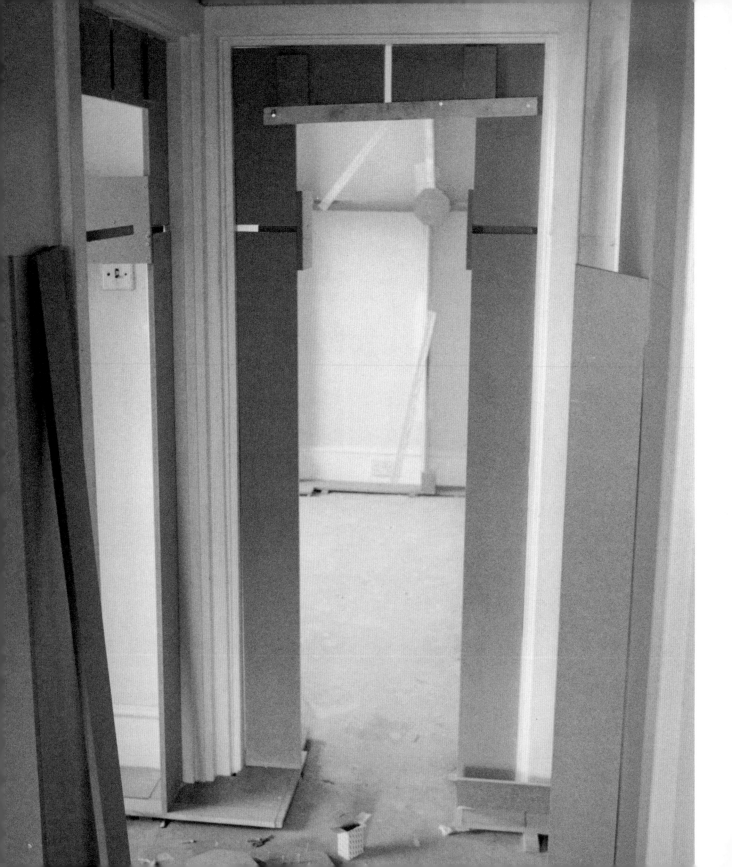

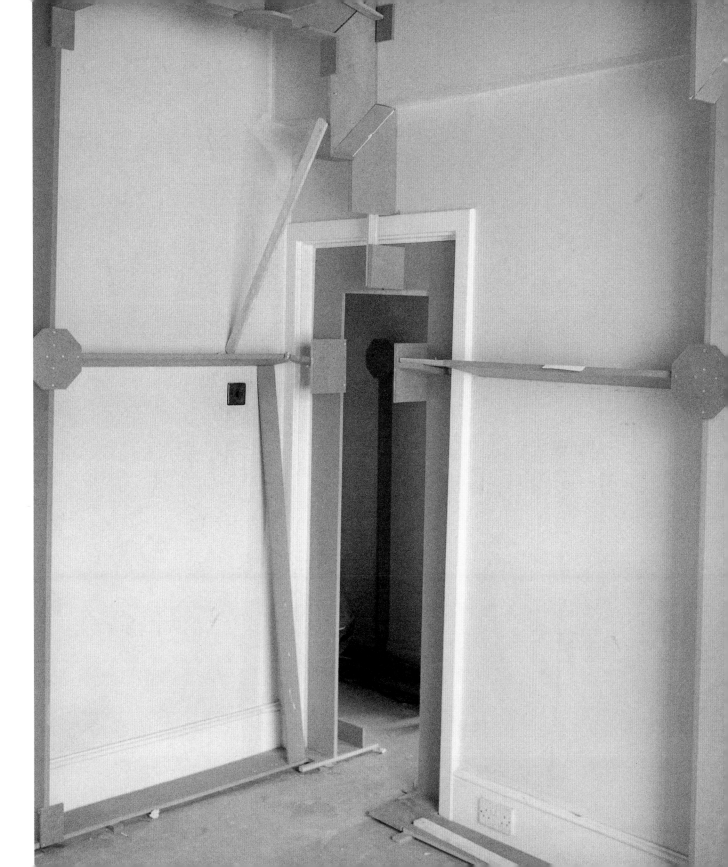

RACHEL WHITEREAD
Transient Spaces

Deutsche Guggenheim BERLIN

Deutsche Guggenheim BERLIN

Deutsche Guggenheim Berlin is a unique joint venture between a corporation—Deutsche Bank—and a nonprofit arts foundation—The Solomon R. Guggenheim Foundation. Designed by American architect Richard Gluckman, the 510-square-meter gallery is located on the ground floor of the Deutsche Bank headquarters in Berlin. Since opening in fall 1997, Deutsche Guggenheim Berlin has presented three or four important exhibitions each year, many of which showcase a specially commissioned work by an artist. The exhibition program and day-to-day management of the museum is the responsibility of the two partners.

Deutsche Guggenheim Berlin joins the Solomon R. Guggenheim Foundation's other locations: the Solomon R. Guggenheim Museum and Guggenheim Museum SoHo, both in New York; the Peggy Guggenheim Collection in Venice; the Guggenheim Museum Bilbao; and two new museums in Las Vegas, the Guggenheim Hermitage Museum and the Guggenheim Las Vegas. Deutsche Bank regularly supports exhibitions in renowned museums, and, since 1979, has been building its own collection of contemporary art under the motto "art at the workplace." The Deutsche Guggenheim Berlin initiative further represents a milestone in Deutsche Bank's advancement of the arts.

Exhibitions at Deutsche Guggenheim Berlin

1997
Visions of Paris: Robert Delaunay's Series

1998
James Rosenquist: The Swimmer in the Econo-Mist*; From Dürer to Rauschenberg: A Quintessence of Drawing; Masterworks from the Albertina and the Guggenheim; Katharina Sieverding: Works on Pigment; After *Mountains and Sea*: Frankenthaler 1956–1959

1999
Andreas Slominski*; Georg Baselitz—Nostalgia in Istanbul; Amazons of the Avant-Garde: Alexandra Exter, Natalia Goncharova, Liubov Popova, Olga Rozanova, Varvara Stepanova, and Nadezhda Udaltsova; Dan Flavin: The Architecture of Light

2000
Sugimoto: Portraits*; Förg—Deutsche Bank Collection; Lawrence Weiner: Nach Alles/After All*; Jeff Koons: Easyfun-Ethereal*

2001
The Sultan's Signature: Ottoman Calligraphy from the Sakip Sabanci Museum, Sabanci University, Istanbul; Neo Rauch—Deutsche Bank Collection; On the Sublime: Mark Rothko, Yves Klein, James Turrell; Rachel Whiteread: Transient Spaces*

Exhibition of works commissioned by Deutsche Guggenheim Berlin

The room in space. The emptiness between the walls in Rachel Whiteread's London atelier has turned into a sculpture that fills the space of Deutsche Guggenheim Berlin. The British sculptor has entitled her exhibition *Transient Spaces*. This may be loosely translated into German as *erinnerte Räume,* or "remembered spaces." The past only lives on when we remember it. Records help us not to forget. The artist has called "recording" the central theme of her art.

Whiteread explores the inner life of rooms and objects. What cannot be seen and yet exists—from the hollowness of a hot-water bottle, one of her first molded castings, to the insides of a two-story house—takes on shape through the artist; it becomes tangible. In most cases Whiteread fills the emptiness and in-between spaces with plaster castings, which she works on further or uses as molds for castings in rubber, polyester resin, or cement. Besides the proportions and composition of the objects created in this way, her attention is on their surfaces which reveal all scratches and details—and in plaster, colors as well. In reference to this technique, Tate curator Emma Dexter has noted the similarities to photography—and the artist herself sees "a wonderful parallel" between this medium and her artwork.

For her Deutsche Guggenheim Berlin commission, the artist has created a casting of the upstairs apartment and basement stairs of her recently acquired London atelier, where she lives and works. It is on the site of a building destroyed during World War II and rebuilt in 1957; it was, before its use as a textile warehouse, known as the Bethnal Green Great Synagogue. In selecting the object, political and personal references are just as important as formal aspects to the artist, who first became familiar with Berlin in 1992 on a DAAD scholarship program. *Untitled (Apartment)* literally fills the back portion of Deutsche Guggenheim Berlin: The viewer is only left with a narrow corridor between wall and object. *Untitled (Basement)* creates a parallel to the stairs of the museum and, with its slim form, presents a contrast to the sheer mass of *Apartment*.

Ghost (1990), one of the artist's earliest casts, has been compared to a temple or sarcophagus. This brings to mind associations of the Pergamon Museum, Berlin, with its archaeological treasures, and a quote from Whiteread in which she describes her art with an illustrative metaphor: "mummifying the sense of silence in the room." This perception by the artist has taken on shape in her sculptures for Berlin. Now it is up to you to perceive your own memories in this silence.

Foreword

Dr. Rolf-E. Breuer

Spokesman of the Board of Managing Directors of Deutsche Bank AG

Since opening in 1997, Deutsche Guggenheim Berlin has invited important contemporary artists to create unique projects relating to the gallery space of the museum. On this occasion, we are pleased to present our sixth commission, featuring a new project by Rachel Whiteread.

Whiteread has consistently received international attention for her sculptures cast from abandoned domestic objects and empty architectonic spaces. The British artist was awarded the Tate Gallery's prestigious Turner Prize in 1993 and a medal at the Venice *Biennale* in 1997. Her work has been the subject of many solo exhibitions in museums and galleries throughout Western Europe and the United States, and she has created significant public projects, including her *Holocaust Memorial* (2000) in Vienna, and *Monument,* unveiled in London's Trafalgar Square earlier this year.

Whiteread's project for Deutsche Guggenheim Berlin draws upon her own experience of this city, where she lived as a DAAD fellow from 1992 to 1993 and addresses the aesthetic and socioeconomic issues related to postwar architecture. Looking for a new home and studio, the artist recently purchased a London building that had been bombed in 1941 and entirely reconstructed by 1957. Cast from a three-room apartment and an enormous basement staircase in the building, Whiteread's two sculptures for Deutsche Guggenheim Berlin—*Untitled (Apartment)* and *Untitled (Basement)*—reveal the simplicity and peculiar proportions of the building's architectural design, which conveys the economic hardship of the times. Anonymous in spirit, the building has readily assumed various identities throughout its history, serving originally as a synagogue, then as a textile merchant's warehouse, and now as the artist's future residence and workspace. Since World War II, architectural distinctions between public and private, as well as the spiritual, industrial, and domestic, have become increasingly blurred, as a growing sense of rootlessness has spread throughout Europe. Whiteread says that she is interested in the "change in use of spaces"—the transience—that has occurred during this period. Hence the city of Berlin, which has been radically transformed several times since the war, serves as an ideal location for the first exhibition of Whiteread's commissioned project.

Many individuals from both Deutsche Bank and the Solomon R. Guggenheim Museum have contributed to the realization and success of this commission and exhibition. Among them, I must first express my gratitude to Dr. Rolf-E. Breuer, Spokesman of the Board of Managing Directors of Deutsche Bank, who has continued to support our program for the visual arts since the museum's opening. We have been fortunate to work with Dr. Ariane Grigoteit and Friedhelm Hütte, Deutsche Bank Collection Curators, who have been encouraging throughout the entire project. In addition, Svenja Simon, Deutsche Guggenheim Berlin's Gallery Manager, and Sara

Preface and Acknowledgments
Thomas Krens
Director, The Solomon R. Guggenheim
Foundation

Bernhausen have provided essential support. Britta Färber of the Deutsche Bank Arts Group has also provided assistance, and Markus Weisbeck of Surface Gesellschaft für Gestaltung has designed many exhibition-related materials.

From the Solomon R. Guggenheim Museum, I am especially grateful to Lisa Dennison, Deputy Director and Chief Curator, for serving as the curator of the exhibition, and Craig Houser, Assistant Curator, for managing all aspects of the exhibition and publication. My appreciation also goes to Jane DeBevoise, Deputy Director for Program Administration; Kendall Hubert, Director of Corporate Communications and Sponsorship; Nic Iljine, European Representative; Marion Kahan, Exhibition Program Manager; Maria Pallante, Associate General Counsel; Anna Lee, Director of Global Programs; and Gail Scovell, General Counsel, all of whom manage the administrative affairs related to exhibition programming for Deutsche Guggenheim Berlin. Other staff members, including Sarah Richardson, Project Curatorial Assistant; Randolph Black, Registrar for Collections Management; and Christina Kallergis, Financial Analyst, have been helpful in the realization of this project.

For their insightful contributions to the catalogue, I am indebted to Beatriz Colomina, A. M. Homes, and Molly Nesbit, as well as to the curators. Susan Sellers and Sarah Gephart of 2x4 have designed an engaging catalogue that provides a clear understanding of the artist's working process. Gautier Deblonde provided wonderful photographs documenting the artist and her staff during the working process.

The Publications department of the Guggenheim Museum in New York expertly manages the production of books for Deutsche Guggenheim Berlin. This catalogue would not have been possible without Elizabeth Levy, Managing Editor/Manager of Foreign Editions, and Elizabeth Franzen, Manager of Editorial Services. I also thank Cynthia Williamson, Assistant Production Manager; Jess Mackta, Assistant Production Manager; Meghan Dailey, Associate Editor; and Jennifer Knox White, Editor. Bernhard Geyer, Uta Goridis, and Marga Taylor translated and edited the texts for the German edition, and Charles Adkins and Jerry Oh, Curatorial Interns, faithfully compiled entries for the exhibition history and bibliography.

On behalf of the artist and the Guggenheim Museum, I wish to offer my gratitude to Anthony d'Offay and Susanna Greeves of Anthony d'Offay Gallery, London, for their support in all phases of the project. Laura Ricketts helped with administrative aspects. Thanks go also to Phil Brown and the rest of the technical team who worked with the artist in her studio.

Finally, my deepest praise goes to Rachel Whiteread, who accepted our invitation and spent many months working to create her extraordinary project for Deutsche Guggenheim Berlin.

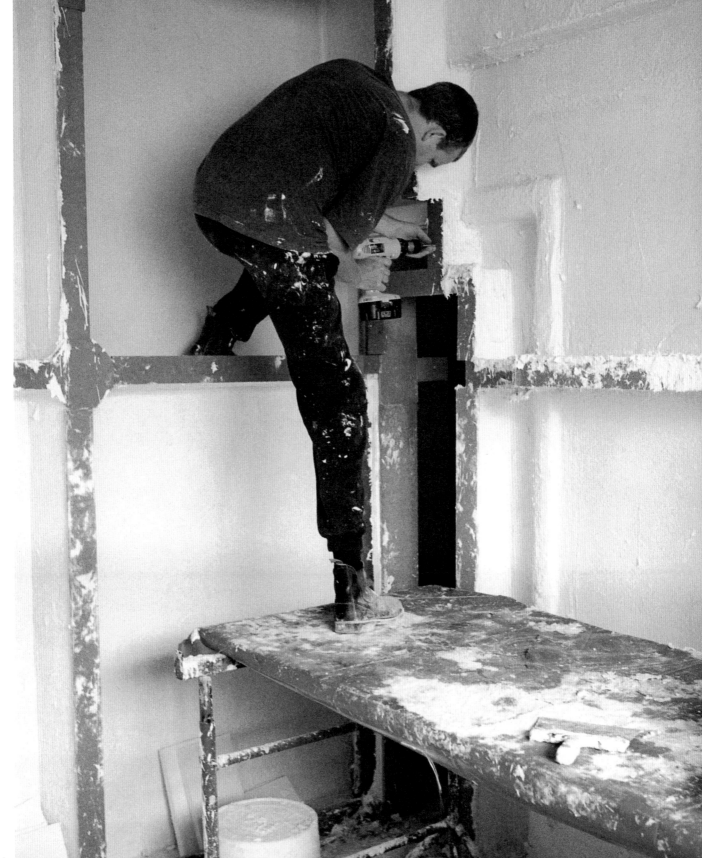

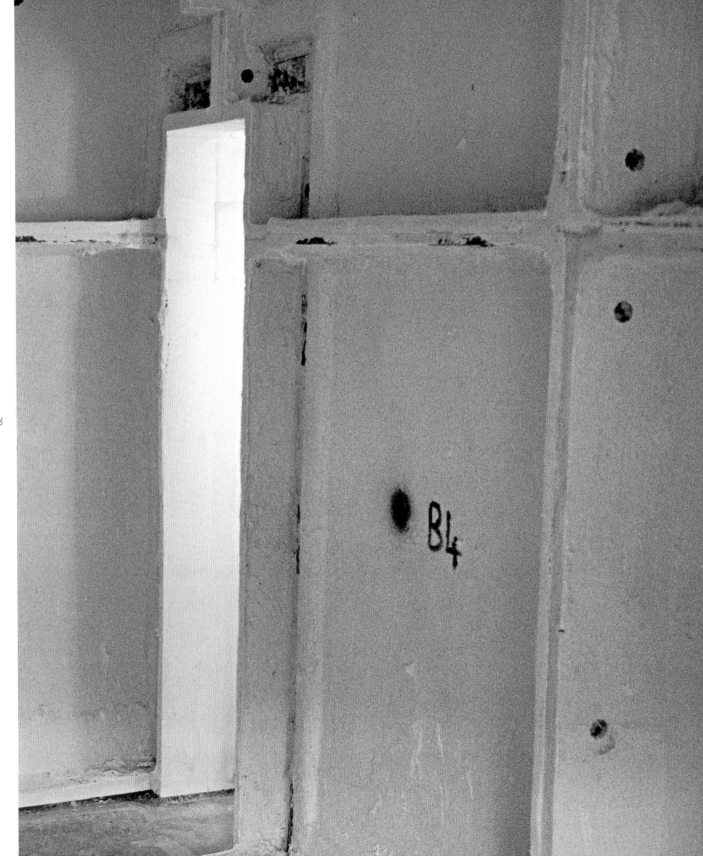

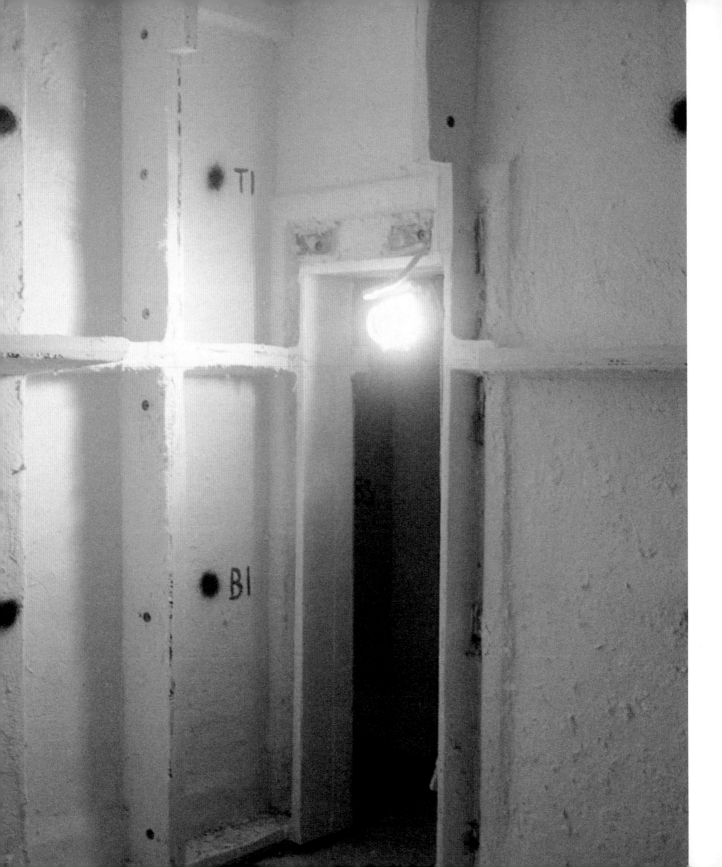

At the end of the 1970s, after almost two decades of relentless experimentation in sculpture, it appeared that every avenue of three-dimensional form and process had been explored. Minimal and Conceptual artists, including Carl Andre, Donald Judd, Dan Flavin, Robert Morris, Richard Serra, Sol LeWitt, Bruce Nauman, Robert Smithson, Eva Hesse, and Joseph Beuys, had inalterably disrupted the paradigms of Modernist sculpture, having taken it off its pedestal; removed from it the hand of the artist; systematized it; employed processes of stacking, scattering, and fracturing; used space as an element; and dematerialized it entirely. Sculpture, at this point, could be made of virtually anything, from industrial materials to fluorescent tubes, to earth, to the human body. Raw materials themselves took on meaning. Value was placed on process over product. Art took on a social conscience. In short, if ever there was a moment in art history where it appeared that everything had been done, it was at this moment of formal and phenomenological exhaustion. But history moves forward, and in the wake of these two extraordinary decades another generation of sculptors emerged, among them Rachel Whiteread. Whiteread seized upon the rich vocabulary and artistic strategies of her predecessors and set on a course to reshape and restage them, discovering the positive through the negative while blending private and public, the personal and the societal.

Born in 1963, Whiteread initially studied painting at Brighton Polytechnic and then shifted her focus to sculpture when she was a student at London's Slade School of Art from 1985 to 1987. Casting has been her chosen medium since early in her career. As a student at the Slade School, she cast parts of her body, sometimes turning them into utilitarian objects, such as the cast of her back that she transformed into a shovel. She considered these student works to be personal and never exhibited them. Ultimately, Whiteread turned to a method of exploring the body by analogy, selecting subjects from the domestic setting of daily life—beds, chairs, bathtubs, and floors—to stand in for, or suggest, a human presence. She would return to her studio after haunting secondhand furniture shops in search of objects with a past and make casts from the objects she had found. In most instances, the interior, made of subtly colored plaster, rubber, or resin, became the art object. The final sculpture was in fact the "negative" of the object itself.

Whiteread's approach evokes obvious parallels with the early career of Nauman. From 1966 to 1968, Nauman explored his relationship to his body and the relationship between his body and the world, serving as both model and mold in experiments that embraced a variety of mediums. He used neon in *Neon Templates of the Left Half of My Body Taken at Ten-Inch Intervals* (1966), wax in *From Hand to Mouth* (1967), and fiberglass in *Six Inches of My Knee Extended to Six Feet* (1967).

A House Is Not a Home:
The Sculpture of Rachel Whiteread
Lisa Dennison

He also explored negative space, creating a fiberglass cast of the "invisible" space separating two illusory boxes in *Platform Made Up of the Space between Two Rectilinear Boxes on the Floor* (1966) and a concrete cast of the space under a chair in *A Cast of the Space under My Chair* (1965–68). He later stated: "Negative space for me is thinking about the underside and the backside of things. In casting, I always like the parting lines and the seams—things that help to locate the structure of an object, but in the finished sculpture usually get removed. . . . Both what's inside and what's outside determine our physical, physiological and psychological responses—how we look at an object."[1] Whiteread saw Nauman's 1986 show at the Whitechapel Art Gallery in London, which included a couple of these early works.

Although Nauman subsequently moved into different territories, increasingly assimilating literary or verbal ideas into his work, casting continued to play a role throughout his career. In the late 1980s, for example, he used taxidermy forms as ready-made molds, and also created installations comprised of suspended anatomical casts of human heads. Like Nauman, Whiteread was intrigued by the casting process for its simultaneous depiction of both the physical fact of an object and its hidden possibilities. She too was interested in the boundaries where interior and exterior come together as one. While Nauman maintained a rough and unfinished quality to his surfaces, defying most conventions of sculpture, Whiteread cultivated the nuances of hers, creating a fossil of the object's history by allowing the casting material to take on the impression of its surface. She revealed the object's past, its "unconscious," so to speak, inventing it anew in its negative state. As such, her sculptures lent themselves to the type of narrative interpretation that artists of previous generations had worked so carefully to avert.

Whiteread calls *Closet* (1988) her first sculpture. The work is a cast of the inside of a wardrobe, covered in a protective layer of black felt. Memory and personal biography come to the fore in this work, which recalls the fears conjured in the artist's childhood imagination by the act of sitting in a darkened wardrobe. Throughout the 1990s, Whiteread continued to use objects imbued with symbolic and often personal import, such as chairs, beds, and baths.[2] In this respect, her work evokes that of Beuys, who used the same mundane objects at the service of his own personal mythology, extending their metaphorical possibilities through the sculptural additions of materials such as felt and animal fat, which he revered for their healing and transformative properties. Beuys argued that all areas of human activity—the social, the political, the spiritual—fall within the parameters of artistic activity, claiming that the molding processes of art act as a metaphor for the molding of society. The seat of his *Fat Chair* (1963), a kind of inverse of Nauman's cast of the space underneath

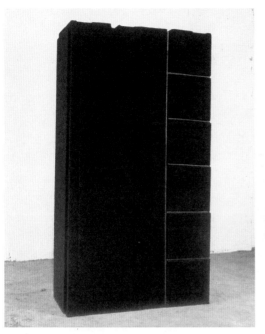

a chair, is filled with a triangular wedge of molded fat that is suggestive of human anatomy and its bodily functions, such as excretion and sex. In *Tallow* (1977), he used twenty tons of tallow fat to cast a desolate corner of a concrete underpass. In transforming a negative volume, a non-space, into a positive sculptural form, *Tallow* became emblematic of the artist's process of using sculpture to surface that which is unseen, rejected, or discarded. Yet in Beuys's work, the sculpture itself never looks like the issue the artist is raising: in *Tallow*, for example, the image is intentionally abstracted and unrecognizable, the material itself carrying the weight of the meaning. Like Beuys, Whiteread forces us to refamiliarize ourselves with banal objects and "to redirect our gaze to that which was an absence, a void, the uncanny spaces beneath the surface of everyday life."[3] But her intention, in contrast to Beuys, is not didactic: she doesn't start with a purpose and seek the means to communicate it, but rather starts from a process that ultimately leads to a personal language and to the work's meaning.

The clearest demonstration of this process is *House* (1993). An ambitious project from its inception (though it had a lifespan of less than three months), *House*

Opposite: Rachel Whiteread, *Untitled (Orange Bath)*, 1996. Rubber and polystyrene, 80 x 207 x 110 cm. The Saatchi Gallery, London. Above left: Rachel Whiteread, *Closet*, 1988. Plaster, felt, and wood, 160 x 88 x 37 cm. Private collection. Above right: Joseph Beuys, *Fat Chair* (*Stuhl mit Fett*), 1963. Wood, fat, wax, wire, 94.5 x 41.6 x 47.5 cm. Hessisches Landesmuseum Darmstadt

1. Joan Simon, "Breaking the Silence: An Interview with Bruce Nauman," *Art in America* 76, no. 9 (Sept. 1988), p. 144.
2. The chair also became a human surrogate in the realm of political responsibility in Nauman's oeuvre in works such as *South America Triangle* [1981].
3. Jon Bird, "Dolce Domum," in James Lingwood, ed., *Rachel Whiteread: House* (London:

became an emblem of Whiteread's work and of its time, speaking to a complexity of issues, from aesthetics to social commentary. The seeming neutrality of its monolithic, chalky-white appearance belied a subject that was psychologically, emotionally, and politically charged beyond even the artist's intentions. Though it was consistent with her oeuvre to date, Whiteread could not have settled on a more loaded symbol when she decided to cast an existing house. A house is a microcosm of the world at large, a shared space, a place of social interaction where basic human needs and desires are fulfilled. A house is also a haven of privacy, safety, and comfort. It harbors the past and the history of its occupants. But it also conjures a darker side, brought to light in feminist discourse of the 1970s, in its connotations as a place of work, conflict, and oppression. Louise Bourgeois's sculpture (which Whiteread acknowledges as an influence) is interesting in this regard.[4] Her works, which are deeply autobiographical, draw on personal obsessions and traumas, triggering memories and associations that encourage a psychic experience of art. In the 1970s, Bourgeois worked with mutable materials such as plaster, latex, and rubber to create beehive-shaped hanging forms—or "lairs," as she called them—that play on the contradictory associations of the home as a place of shelter and as a place of entrapment and vulnerability.[5] Bourgeois's sculpture maintains its associations with architecture to the present day. Her series of "cells"—partly enclosed shapes defining interior areas replete with objects that are often domestic in nature—are, like her "lairs," both a place of haven and entrapment. This instability is heightened by the voyeuristic role in which Bourgeois places the viewer, who stands outside the piece, peering in through windows and other openings.

Like Bourgeois, many other artists of the post-Minimalist era took their sculpture a step closer to architecture, or used architecture to position the viewer in a different relationship with the artwork. Nauman's work, for example, shifted away from the body in the 1970s, toward quasi-architectural installations in the shape of corridors or rooms. In these works, he expanded upon the opposition of inside and outside found in his earlier work. His narrow corridors constructed of wallboard exposed their wooden structures on the outside. Nauman also induced a sense of claustrophobia or disorientation in these works, exploring human behavior in discomforting situations by placing viewers in compressed spaces, often with various lighting, audio, or surveillance devices. Other artists of the post-Minimalist era, such as Robert Smithson and Michael Heizer, destabilized the relationship of the work to the gallery context by taking sculpture to the landscape. Heizer's *Double Negative* (1969), for example, is purely an art of reduction, comprised of two deep trenches created through the removal of vast amounts of earth from the Nevada desert. Meaning is

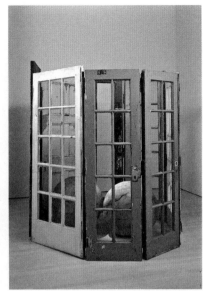

**Above left: Rachel
Whiteread, *House*, 193 Grove
Road, London, 1993
(destroyed 1994). Concrete.
Above right: Louise
Bourgeois, *Cell V*, 1991.
Wood, glass, paint, and
metal, 232 x 209.5 x 204.5
cm. Solomon R. Guggenheim
Museum, New York 92.4006**

derived from the space that is left. It is up to the viewer to visualize these voids combining to create a "double negative." Whiteread's *House* and other sculptures she has created based on architecture resonate with both the psychic spaces of Nauman's and Bourgeois's sculptures, and the negation and displacement that Smithson and Heizer introduced into their work.

For *House*, Whiteread selected a rather nondescript Victorian-era terrace house in a working-class neighborhood in London's East End that had been slated for demolition. Concrete was sprayed over the interior so that when the building itself was pared away, the solidified interior space was revealed. The sculpture stood proudly on its site, mute, implacable, and inert on one level, replete with history and association on another. The public debate over whether or not Whiteread's sculpture should be retained or dismantled soon became a topic of national proportions, raising issues concerning community, gentrification, the state of housing in London, what is private and what is public, and the role of public sculpture. But despite the critical discourse that evolved around *House*, the work itself did not strive for the status of a monument. (Indeed, Whiteread's art in general is antimonumental, despite its scale.) Nor did it proclaim to the world the heroic nature of the process that brought it into being, unlike Gordon Matta-Clark's *Splitting: Four Corners* (1974),[6] in which the

Phaidon Press, 1995), p. 122.

4. See Andrew Causey, *Sculpture Since 1945* (New York: Oxford University Press, 1998), pp. 137–38.

5. For a discussion of this work as it relates to these issues, see Alex Potts, *The Sculptural Imagination* (New Haven: Yale University Press, 2000), pp. 361–70.

6. See Lynn Zelevansky, *Sense and Sensibility: Women Arts and Minimalism in the Nineties*, exh. cat. (New York: The Museum of Modern Art, 1994), p. 29; and Robert Pincus-Witten, "Gordon Matta-Clark: Art in the Interrogative," in *Gordon Matta-*

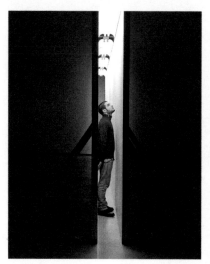

artist literally cut through the center of a modest suburban home to form a wedge-shaped space bisecting the building, and then cut again through the four corners of the second floor. Whiteread, like Matta-Clark, was interested in exposing that which is usually unseen in a building, but Matta-Clark's operation was more aggressive, a gesture of liberation for the suburban home, which he believed to be the by-product of a capitalist desire to enforce a compartmentalization of the middle class. He stated, "By undoing a building, I open a state of enclosure which had been preconditioned not only by physical necessity but by the industry that [proliferates] suburban and urban boxes as a context for ensuring a passive isolated consumer."[7] Like Matta-Clark, Whiteread also challenged the notion of the home as an immutable entity, but her process of "undoing" a building was not a question of social reform or social critique; rather, it posited a particular set of questions, the outcome of which was by no means predetermined. And making it work in sculptural terms remained her over-riding concern. Other artists of Whiteread's generation have explored the confluence of sculpture, architecture, and even design as a means of transforming the viewer's relationship to his or her environment. Robert Therrien, for example, makes sculptures based on the reductive forms of Minimalism and on domestic objects such as beds, tables, and chairs, which are infused with a figural quality and humor. Ann Hamilton's photographs of household furniture appended to her body extend the exploration of the body through its surrogates. Mona Hatoum has created cage-

like environments and cubic sculptures that convey oppression and alienation, and Gregor Schneider reconstructs rooms from his home within the museum, creating new spaces that are physically and visually disorienting and that blur the lines between reality, art, and architecture.

House can be seen in the lineage of architectural-scale projects that have spanned Whiteread's career, from *Ghost* (1990), in which she cast a parlor room in an abandoned Victorian row house, to her *Holocaust Memorial* in Vienna (2000) and *Untitled (Apartment)* and *Untitled (Basement)* (2001) for the Deutsche Guggenheim Berlin. While integrally connected, the projects differ in process, materials, form, scale, and surface. *Apartment* involved the complicated process of casting a multiroom structure, requiring Whiteread to solve the problem of how to depict the gaps in the structure where the walls once existed. *Basement*, also a virtuoso feat of casting, recalls Constructivist sculpture in its dynamic instability: the staircase is positioned on its side and yet ascends at the same time. Like Vladimir Tatlin's utopian *Model of the Monument to the Third International* (1920), it both thrusts upward and finally succumbs to the force of gravity, its material weight dragging it back to an earthbound state.[8]

In the reactions they provoke, as well as in the attitude the artist manifests in their creation, Whiteread's architectural projects wittingly or unwittingly alternate between a cool, somewhat distanced mode, and a more emotionally charged state. The Guggenheim commission strives for the former category, almost in defiance of the potential minefield she has entered by casting parts of her future home and studio, a building that was once a synagogue. Undoubtedly sensitized by the politics surrounding her recently completed *Holocaust Memorial*, Whiteread refuses to over-elaborate on the building's past, or to read into its previous incarnation as a synagogue. She does acknowledge, however, that *Apartment* and *Basement* are mappings of the building and its layers of history. Dampening the aspects of memory and nostalgia that might otherwise surface, Whiteread selected a casting medium that would leave the surfaces of the sculptures unmarked, rather devoid of the residue of past occupancy that exists on the surfaces of much of her previous work. The sculptures maintain a self-effacing quality, a sense of humanity and humility that underlies all of her projects, despite their size and ambition.

Whiteread's decision to bring her own architecture to the Guggenheim Museums in Berlin, Bilbao, and New York derives from her astute understanding of the specifics of a site. The works will serve as a foil to the three architectural locations at which they will be exhibited. Her decision also reinforces the distinction between her sculpture and architecture itself. The contrast between her work and the Bilbao museum

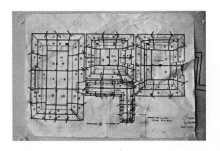

Opposite left: Bruce Nauman, *Green Light Corridor*, 1970. Painted wallboard and fluorescent light fixtures with green lamps, dimensions variable, approx.: 304.8 x 1,219 x 30 cm. Solomon R. Guggenheim Museum, New York, Panza Collection, Gift 92.4171. Opposite right: Michael Heizer, *Double Negative*, Mormon Mesa, Nevada, 1969. Rhyolite and sandstone, 240,000 tons displaced, 457.2 x 9.14 x 15.24 m. Museum of Contemporary Art, Los Angeles. Above: Construction plan for *Untitled (Apartment)*, 2001

Clark: A Retrospective, exh. cat. (Chicago: The Museum of Contemporary Art, 1985), p. 11.
7. Gordon Matta-Clark, quoted in Causey, *Sculpture Since 1945*, p. 200.
8. Many Minimalists acknowledged a debt to Constructivist sculpture in terms of materials, fabrication methods, and the architectural quality of their work.
9. Much has been written on the topic of death in Whiteread's work—the references to the death mask, her use of coffin-like forms and mortuary slabs—as well as the issues of memory, nostalgia, and commemoration.
10. See Neville Wakefield, "Rachel Whiteread: Separation Anxiety and the Art of Release," *Parkett* 42 (Dec. 1994), pp. 76–89.
11. Fiona Bradley, "Introduction," in *Rachel Whiteread: Shedding Life*, exh. cat. (Liverpool: Tate Gallery, 1996), p. 17.

is particularly apt. Frank Gehry's building is a spectacle of architecture, with its gleaming titanium surface that proclaims itself in no uncertain terms; its presence overwhelms as a constant, phenomenal object. In contrast, Whiteread's sculpture, though architectural in theme, has an underneath, an unconscious of sorts; it's everything *but* a visual phenomenon. Her art maintains the antimonumentality of the workplace where her sculptures were cast, as well as the signs of hand-wrought labor and process—qualities that were introduced by women artists such as Hesse in the late 1960s. The scale and proportion of her pieces are predetermined by the originals. Her materials evoke a fragility, a vulnerability, preserving always the human trace; in this way, her work is akin to one of the earliest sculptural practices, the death mask. Like the death mask, her work is both a "portrait" of the original building as well as an object in its own right that will begin to accumulate its own particular history.[9]

Minimalist sculpture has been deeply involved with enclosing an interior space (hence the prevalence of the "box" as a form), and yet at the same time it divests the sculptural object of internal psychological space, literally relocating the sculpture's meaning to that which is outside it. Not only is the sculpture's spatial context all-important, but so is the position of the viewer in relation to it. Whiteread has given a great deal of attention to this central tenet of Minimal art in her work, playing with and against it. Her works demarcate an interior space, yet this space is the negation of the thing itself. This interior, or negative, holds tightly onto the work's meaning. Absence becomes presence. And in the present relationship the works have with their viewers, the realm of encounter is a psychological as much as a formal one. Finally, in order to understand the space or object being viewed, it is necessary for the viewer to position her- or himself quite literally in the space from which it came—what has been described in the literature on Whiteread as "the space of release"[10] or "the mental position adjacent to that space."[11] Attaching the classical idea of casting to works whose social implications are far-reaching, that contain memory and nostalgia, and in which emptiness becomes matter, Whiteread's art has the staying power of the monument without its pomposity. And unlike her Minimalist predecessors, it speaks of everything else about the thing other than its "thingness."

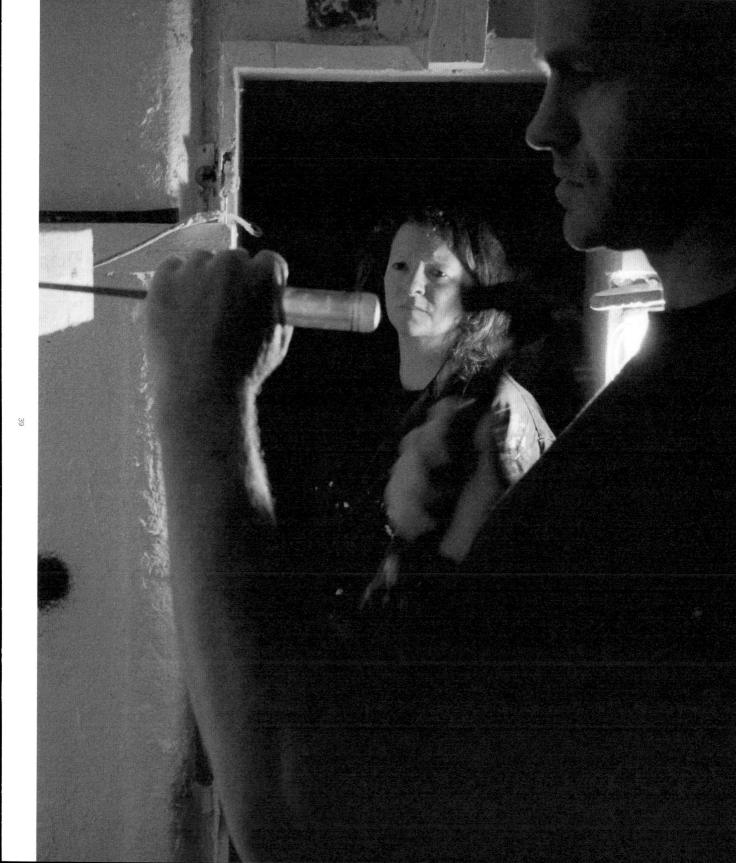

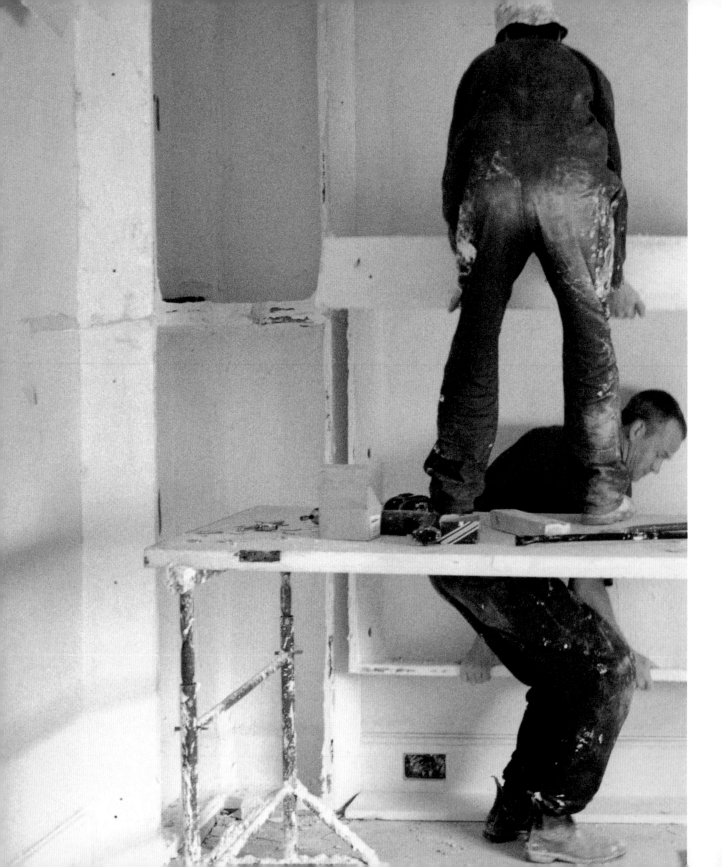

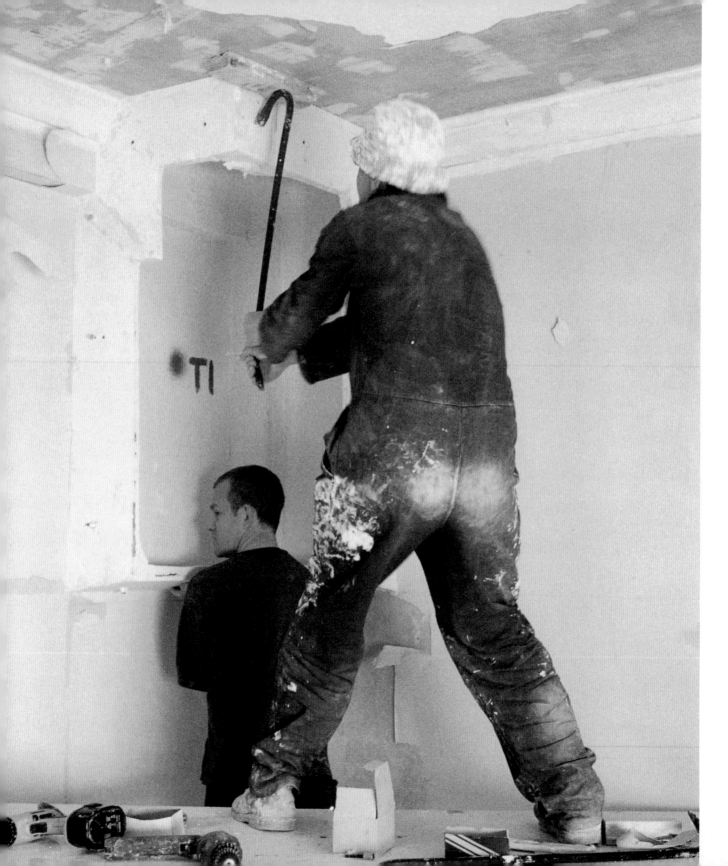

CH: You recently purchased a building that will become your new home and studio, and you've been making your most recent body of work there before you move into the space. What first attracted you to this building?

RW: My partner, Marcus Taylor, and I were looking for a new studio and apartment, and he was the one who actually found the building, one that I'd driven past and walked past for fifteen years, but had never, ever noticed. There was originally a Baptist church on the site, and then it became a synagogue in the early 1900s. During World War II, the site was bombed and the present structure was built in the mid-1950s. Less than thirty years later, the synagogue closed and a textile company used the building as a warehouse for about the next thirteen years or so. Then it was empty. So by the time we arrived, there were already varied layers of history present in the building.

CH: You've worked with many different buildings in creating your sculptures. How did this particular one intrigue you from the point of view of an artist?

RW: Really, the anonymity of it. The building is made of a stock brick—an anonymous sort of brick. Architecturally, it reflects a mishmash of styles—both semiindustrial and semidomestic. There are two Stars of David and three stained-glass windows on the face of the building, but other than that, you wouldn't think it was originally a synagogue.

I began by thinking about the minutiae of the building, in terms of how one might change it and translate it into something more modern. I was really considering it in terms of living there, possibly for the rest of my life. I had never really thought about the details of a space in this manner before, except in terms of sculpture. So while I was busy being totally absorbed with the building and thinking about working with architects, I became drawn to the idea of creating a series of works related to the apartments, the staircases, and the floors.

CH: Tell me about the basement staircase and the upstairs apartment where you made the casts for your commissioned project for the Guggenheim.

RW: My decision to cast these two parts of the building had a lot to do with the odd proportions of the architectural design. The building has three staircases, which are made of concrete and feel industrial. The one I chose to cast for the Guggenheim leads to an enormous basement, which you would not expect to find as you walk around the place. In some ways the building is much larger than one might think.

There are two apartments; I believe one was built for the rabbi and the other for the caretaker of the synagogue. They're just spaces that have been blocked into small rooms. They look like archetypal council flats, really—each is made up of small rooms leading off a main corridor, and usually the rooms are based on the proportions of an

If Walls Could Talk:
An Interview with Rachel Whiteread
Craig Houser

arm span. A lot of rooms are based on that width. You can just get a bed in. We're not going to keep any of that when we live there.

CH: Do you see your project, then, as a way to archive the building?

RW: In a way. It's almost like taking photographs or making prints of the space. If those parts of the building don't exist later, I'll still have, as you say, this archive of the place.

CH: I came across a recent book titled *The Lost Synagogues of London* and spoke to the author, Peter Renton. He has a reproduction of your building in his book and gives a little history of the congregations, but he said that apart from that there really isn't much information about the building itself. During my research, I kept thinking about how your building has readily changed hands and functions in a relatively short period of time, and how it seems like an abandoned object in some ways.

RW: When Marcus and I first visited with the estate agent, there was a definite sadness to the building. I remember that it was full of all this weird, glittery fabric and other strange material that the textile company had left behind. Marcus and I spent about a month combing through all the stuff, just thinking about it. Not that we wanted any of it. It was our way of getting to know the place.

CH: Were you specifically interested in the building in terms of its history as a synagogue or any of the larger Judaic themes that might relate to it?

RW: No, it just happens that we purchased this building. I didn't go and look for a synagogue, either to live in or make work in. I'm interested in the layering in buildings, and the traces that are left behind by the change of use of places. My work is really about the strange kind of architecture that cropped up during the postwar years.

CH: I'm curious what you mean by that. Are you interested in the impersonal nature of such architecture?

RW: In London, there were enormous areas of devastation from bombing during the war, especially along the Thames and in the semi-industrial areas. A lot of houses and accommodations were flattened, and there was a rush to rebuild. I am being somewhat simplistic here, but with the massive rebuilding, we ended up in the 1960s with these residential building complexes that I suppose symbolized hope, and were full of optimism and good intentions, but had a very different outcome in reality. I made a series of prints a long time ago called *Demolished* [1996], which documented these types of tower blocks being blown up in the 1990s. Now they make these awful buildings that are mock-Victorian, mock-Georgian houses, which have similar facades to the houses that are around this area, but the rooms are still based on the arm span.

CH: Your new building is located in East London, where you've created other proj-

ects in the past. I'm wondering what intrigues you about this area, specifically the neighborhood of Tower Hamlets.

RW: I've actually lived around this area ever since I moved back to London after studying in Brighton, about sixteen years ago. The neighborhoods around here—Hackney and Tower Hamlets—may feel a bit derelict and alien to some, but for me, they are my sketchbook. What makes the area wonderful is that it reflects a great cross section of London—a big bowl of world soup. There's a large Asian community, a Jewish community, an Afro-Caribbean community, and something of a Turkish and Serbian community. I find it a very rich and vital place that's really full of history. The area, like my building, has experienced significant changes recently. It was originally part of the slums of the old East End, and it's now becoming more gentrified.

CH: Your Guggenheim pieces were commissioned by Deutsche Guggenheim Berlin specifically, and your show will travel to the Guggenheim Museum Bilbao and the Solomon R. Guggenheim Museum in New York. Since much of your work is about architecture, did these sites enter your thoughts in any way while you were working on the commission?

RW: Well, I'm afraid I'm old-fashioned and still think the "Guggenheim" is the Guggenheim in New York. I realize the museum has expanded, but when I was first approached by the Guggenheim, I thought of the fantastic building by Frank Lloyd Wright, who is a great hero of mine. The rotunda is the most extraordinary sculptural object. Sometimes I wish it was just left empty. So I was thinking about that building, and wondered how I might compete with the rotunda. I think a lot of people have had trouble doing that. I also thought about the other Guggenheim buildings in general. The Deutsche Guggenheim Berlin is a long, narrow gallery. It's beautiful, but it's not unique, like the Guggenheim in New York or in Bilbao.

Initially, I thought about how I could relate the different Guggenheims to one another. Then I thought, "Why don't I bring my own architecture to the museums, rather than the other way around?" And that is why I've used my own building.

CH: From what you're saying, it seems that *Untitled (Apartment)* will relate to the Deutsche Guggenheim space most directly. *Apartment* and the gallery space are both long and narrow, geometric and austere. *Apartment* is also quite large and will just fit within the gallery space.

RW: It's nice that the show will be there first, because *Apartment* and the gallery space definitely relate. Although I don't like to plan exhibitions on paper, I do think *Apartment* will feel a bit like a maze in the gallery. You'll be able to walk around part of the piece, but then you'll have to back out, and go around the other way. So you'll never really see the piece as a whole.

CH: As an artist, many concerns must be on your mind as you create your works. Was there any one thing in particular that you focused on while making this piece?

RW: For me, *Apartment* has a lot to do with figuring out how to cast a many-roomed apartment and show the space where the walls were between the rooms. When I made *House* [1993], we had to leave the actual walls and floors in place. We could not knock them out. But with *Apartment*, everything was cast around the architectural elements and the casts were removed in sections. So when you look at the piece, there is a space between the rooms where the wall once was. We did an awful lot of casting for six months in order to make this space. The engineering and crazy gymnastic backward thinking that was needed to be able to make the piece was remarkable. That's really how I think about it.

CH: So is this the first time that you've let wall spaces exist between rooms?

RW: Yes. *Apartment* will consequently have these very weird gaps, especially since the architecture itself wasn't really thought out. You will be able to peer down these narrow negative spaces and just glimpse where the light fittings and light switches once were. There are a lot of electrical elements that you can't see, but trust me, they're there, as they would be within any normal building. It is incredibly important to me that these details have to be right. I have to be honest in what I am doing.

CH: You mentioned to me once that *Apartment* is unusual because it has a ceiling. Can you elaborate on that?

RW: When I was thinking about making *Apartment*, I was very clear that I wanted it to be a series of cubes that fit together and that there had to be ceilings on them. All of the light fixtures are part of the piece. So when you see the piece from above, there's a kind of belly button to the piece, and along the corridor a series of indentations from lights.

CH: Is your other work for the Guggenheim, *Untitled (Basement)*, the first staircase piece you've ever made?

RW: Yes. It's something that I've been trying to do for about eight years. What intrigued me about the staircase is that I felt it could be turned on its side.

CH: In the past, you've always been true to form with your architectural pieces. What is your intention in putting the staircase on its side?

RW: When I was first thinking about making *Basement*, I didn't necessarily want to illustrate it as a staircase. If I had, I would have had to either peg the bottom to the floor or lean the top part against the wall. I wanted to try to do something a bit less literal. I made models of the staircase, which helped me realize that I could actually turn things around. You can't do that when you've got a sculpture over three meters high.

CH: I see the staircase and I wonder if there's a link with any of the Guggenheim

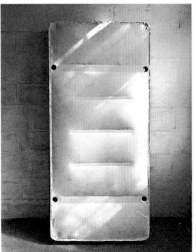

buildings. The reason I ask is that the Guggenheim in Bilbao is an unusual building in which forms appear turned around. Even Frank Lloyd Wright's structure in New York does this in its own way.

RW: I think that's a very good observation. I was thinking for this piece that I wanted to try and flip the architecture a little bit. I wanted to change the way one might think about how you walk around or through something, which is what the New York and Bilbao Guggenheim buildings do. When we first put the staircase work up in the studio, I remember I was struck by the sense of physical disorientation it gave me.

CH: I would like to ask you more about your work made prior to *Apartment* and *Basement*. Your early pieces are noted for their ability to conjure up memories and stories. How do you see your work doing that?

RW: Some of my very early works do so partly due to their titling. Works with titles, such as *Yellow Leaf* [1989], *Closet* [1988], *Shallow Breath* [1988], and *Ether* [1990], make you look at the pieces in a certain way. Also, the history of the objects used in some of the earlier works is much more evident in the surfaces of the final sculptures.

CH: What did you do to create that type of surface?

RW: Well, with *Yellow Leaf*, for example, I cast a piece of furniture that was very similar to my grandmother's kitchen table. All the coloring on the surface of the work is the actual coloring from the underside of the table. In order to make the color more

Above left: Rachel Whiteread, *Yellow Leaf*, 1989. Wood, Formica, and plaster, 149.8 x 73.6 x 93.9 cm. Fundação Calouste Gulbenkian/CAMJAP, Lisbon. Above right: Rachel Whiteread, *Shallow Breath*, 1988. Plaster and polystyrene, 185 x 90 x 20. Private collection

intense, I used cooking oil as a release agent to separate the cast from the object. So there's this slight yellowing on the surface of the sculpture. But there are also all sorts of bits of horrible stuff that you find underneath tables.

CH: Chewing gum and the like?

RW: All that kind of stuff is there on the surface of the work. I managed to pull things from the object being cast, reflecting the layers of its history.

CH: Another early work, *Shallow Breath*, relates to your personal history. The work was made from a bed you were presumably born in.

RW: No. People always think that. I'm sure you read it somewhere.

CH: I read it several times.

RW: People think that I was born on that bed, and people also think that my father died on that bed. I actually bought the bed in a secondhand shop. In fact, I've never used an actual object that's been directly related to my family history.

CH: You've said that furniture functions as a "metaphor for human beings," and all of your furniture pieces—your bed pieces in particular—tend to evoke absence and loss. This is especially true of your casts that exist as negative impressions, which reveal the forms of their original objects in detail, but not their physical presence.

While you were making your furniture sculptures, you also began to create architectonic pieces. In 1990 you made your first one, *Ghost*, which is a cast of a parlor room in a Victorian house.

RW: Yes. That was the first time I really thought about trying to be ambitious in my work. I remember I said that I wanted to mummify the air in a room, which is what I was writing in my proposals to try to raise the money to make the piece.

CH: The very title of the work conjures up death and remembrance, and in fact the work has been interpreted as a mausoleum. Like your furniture pieces, *Ghost* documents the shape of something, yet notes its very absence. The structural logic of architecture has been inverted: inside has become outside; space has become solid form.

How did you go about creating this first large-scale work?

RW: *Ghost* was hand cast, and I made a lot of it entirely on my own. It was the first piece in which I realized that I could absolutely disorient the viewer. While I was making it, I was just seeing one side at a time. I then took all the panels to my studio and fixed them to a framework. When we finally put the piece up, I realized what I had created. There was the door in front of me, and a light switch, back to front, and I just thought to myself: "I'm the wall. That's what I've done. I've become the wall."

Ghost was naively made and put together, and it's extraordinary that it still survives in such a good state today. It's still there, holding on, with lots of fiberglass

around the back of it now to support it. I've since learned how to make things in a completely different way.

CH: Your process has changed considerably over time. What are the differences between *Ghost* and *Apartment* as a result?

RW: With *Ghost*, there are slight gaps between some of the panels, and there is no ceiling, so chinks of light come through. With *Apartment*, everything is fitted very tightly together, and the top is sealed off so it's dark inside and no light comes through.

Also, on the surface of *Ghost* you can see lots of soot from the fireplace, whereas with *Apartment* and *Basement* I used a blank release agent, so that although you see the edges of the wallpapering and the paint marks on the wall, there are no nicotine stains or ventilation stains where windows have been opened and pollution has come in. I quite deliberately made the surfaces of the pieces blank.

CH: The simple geometry of *Apartment* and *Basement* is therefore emphasized and their sense of "individuality" is less apparent. In 1993, you unveiled *House*, your first public sculpture in London, which was commissioned by James Lingwood of Artangel. How does this piece compare with *Apartment*?

RW: For *House*, we used a Victorian house as the mold, and then destroyed it. We just took the house down around the piece, which stayed where it was. For

Above: Rachel Whiteread, *Ghost*, 1990. Plaster on steel frame, 269.2 x 355.6 x 317.5 cm. The Saatchi Gallery, London

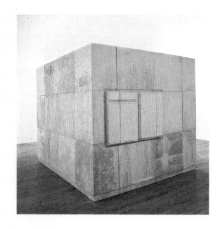

Apartment, we didn't destroy the mold; we kept it. Everything was cast in sections, so we could get the piece out of the rooms of the apartment.

CH: With *House*, you also took numerous photographs of the house before you began casting. Were you interested in the personal stories related to the house?

RW: No. When I made *House*, I met the previous occupants, Mr. [Sydney] Gale and his daughter, and we kept in touch for a while. But actually, it made me feel a little bit uncomfortable. It was like I'd cast their history. I didn't want to intrude in that way.

CH: *House* stimulated strong reactions from the public—both positive and negative—and eventually was destroyed. Was it intended to be temporary from the start?

RW: *House* was always supposed to be temporary. It was there for just three months, and for a while I was hoping for a sort of reprieve, so that the piece could have a good six months in its situation and become part of the city, rather than the moment of madness that it was.

CH: The same year you unveiled *House*, you also created *Untitled (Room)*.

RW: In 1992–93, I had a DAAD fellowship and lived in Berlin for eighteen months. I created *Room* while I was there. I see *Apartment* and *Basement* as extensions of this piece.

CH: I read that about the time you made *Room*, you decided to create work that was less concerned with nostalgia and recollection. You seem to have moved away from the fancy trimmings of nineteenth-century architecture to favor simplified geometric form, which *Apartment*, *Basement*, and *Room* all have in common. These works feel more impersonal, neutral, and even standardized in comparison to many of your early pieces.

RW: *Room* was actually made from a fictional space. I made a plywood mold for the room, as if it were a prop. It had one window, one door, and looked just completely blank. It didn't even have a light switch or any electrical bits in it. The work represents a generic space.

CH: *Room*, like *Apartment*, recalls the low-income housing of the postwar period and the formulaic approach to its making. You've made some changes in the type of space you cast and in the way you go about the process, but is there anything your room pieces share?

RW: All of my room pieces—or any architectural pieces I've made—really have to do with observing. There's a sense of puzzlement in just looking at them and thinking: "We live in that kind of place. How do we function physically within a place like that?" This is definitely what I do when I look at my works. I think about how they affect me physically.

CH: I would like to discuss the influences on your work. I think of American Minimalism right away, as well as other movements of the 1960s and 1970s

including Process art and Conceptual art. In the past, you've talked about Carl Andre and Richard Serra, and you've also mentioned Eva Hesse and Bruce Nauman. I'm wondering more specifically what ideas and practices from this period intrigue you.

RW: I would say there's an American influence in my work, specifically American art from the 1940s onwards. I think it has a lot to do with the scale and ambition that American artists had at that time, particularly in sculpture, that had never really been seen before. They had this incredible kind of freshness.

CH: Who else then?

RW: Gordon Matta-Clark, Tony Smith, and Louise Bourgeois. All sorts of people have crept in.

CH: How do you see your work differing from, or reversing, the tropes of Minimalism?

RW: Well, somebody once said—and I hate this as a quote—that what I do is "Minimalism with a heart." I suppose there is a certain kind of feminine touch that I use with materials and color. I try to make things look easy when, in fact, they're incredibly difficult. Someone like Serra does this as well. He uses these extraordinary masses, yet the best pieces look completely effortless. My response to sculpture is often physical, the physical way in which you look at something. Serra is a perfect example of an artist who does that. He changes your perception of how you put one foot in front of the other when you're walking around or through something. What happens is that you think about your physical place in the world.

CH: Do you see your work relating to his in terms of scale?

RW: Well, *House* was a large piece physically. It was bigger than a Serra, or rather, some Serras. But it was also very simple and very humble. It was about where we live, where we come from, where we sleep, where we have families. I think it therefore shrank and became much smaller than its physical space. If you stood beneath *House*, it was monumental, but when you walked a little bit down the street, it just looked kind of pathetic. So my work is different: you could never describe a Serra as looking pathetic. Or an Andre. There's a pathos about what I do. People respond to the sense of humanity that's in some of my works, which isn't in a lot of other artists' works.

CH: Some of your pieces make direct reference to works by a few of the artists we named before. You refer to Nauman's *A Cast of the Space under My Chair* [1965–68], for example, in *Untitled (One Hundred Spaces)* [1995], which is made up of casts from one hundred different chairs. What is your strategy in creating a piece like that?

RW: *One Hundred Spaces* was one of a series of chair pieces. I'd actually forgotten that I'd seen the piece by Nauman at a show that Nick Serota curated for the Whitechapel Art Gallery in London many years before. I just hadn't really noticed

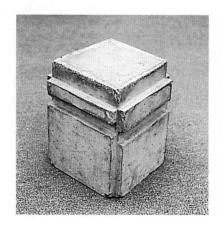

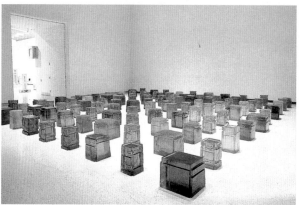

Nauman's piece at the time. I think I used the space under chairs for all sorts of other reasons. For me, it was a step to making an absent place for one person—or in the case of *One Hundred Spaces*, an audience of people.

CH: To me, the experience of Nauman's piece is quite different from that of *One Hundred Spaces*. I think you paid more attention to the formal details of the objects you worked with than Nauman did. You also used a variety of colors and different kinds of chairs, and the translucent resin material you used gives the work a somewhat ghostly, religious feel.

RW: The more I showed or gave lectures in the United States, people would say: "You're just making Naumans!" And they would get really cross. I felt like I had to backtrack and even defend myself. I recognize that Nauman is the source where this series initially came from, but I think it's doing something different. It's up to you whether or not you think it's doing something else. I suppose the situation is similar with Carl Andre. . . .

CH: You've been making floor pieces since the early 1990s. You told me that you want to place *Untitled (Cast Iron Floor)* [2001], which you cast from the floor in your new building, in the entryway to your exhibition at the Serpentine Gallery opening in London in June [2001].

RW: We cast four floor pieces in the synagogue, first in plaster, and then we translated them into metal. The casting inverts the surface texture of the floor, such that the areas where the grout originally went inward become the raised parts of the finished piece. We then applied a mixture of black patina and wax by hand across the surface. The idea is that as visitors continue to walk over the piece, their feet will buff the raised areas. Eventually, the patina will be removed and the raised areas will

shine, revealing the grid pattern of the original floor. In the end, I hope to achieve an effect like an Agnes Martin painting.

CH: You originally trained as a painter at Brighton Polytechnic and then focused on sculpture at the Slade School of Art. Is there any way you see yourself still as a painter?

RW: No. I definitely see myself as a sculptor. But I do enjoy the painterly aspects of these recent works, and some of my book pieces have a lot of color. I also like to make a lot of drawings, which I think is where my former painting studies mainly come out today.

CH: Whenever I look at your work, I'm always struck by your choice of materials.

RW: I'm very interested in the materials that are around us all the time, how they happen to be there, what they do, and how things are made. Initially, I was especially curious about rubbers and plastics. But I use different materials for all sorts of reasons. For projects like *Apartment* and *Basement*, I knew I didn't want to make it in rubber or plastic. The piece had to be light and white. I wanted to get the same kind of surface as plaster, but I wanted to use a material that was far more robust. So after a lot of research, we found a type of plasticized plaster. It's an elemental material that comes from the earth. You can add stone dust to the material and a liquid agent. It's much like fiberglass, but it's safer to use and, I think, looks better.

CH: Do you choose materials based on the object you're casting?

RW: No. For example, with the bed pieces I made two or three in plaster, two or three in rubber, a couple in polystyrene.

CH: Does the plasticized plaster you used for *Apartment* and *Basement* do anything different from other materials you have used, in terms of the look or the associations attached to the pieces?

RW: No, not really. Earlier in my career, I never wanted my pieces to have that hollow sound if they were ever hit. They had to sound solid. But *Apartment* and *Basement* have a hollow sound to them, which I don't mind because I have moved on.

CH: In October 2000, after five years in the making, your *Holocaust Memorial* was finally unveiled in Vienna's Judenplatz, which is largely a residential square. For the project, you created a single room lined with rows and rows of books, all of it rendered in concrete. There is a set of closed double doors in front, and the names of the concentration camps where Austrian Jews died are listed on the platform surrounding the memorial. The piece is near the Holocaust Museum in Misrachi Haus, and sits to one side of the Judenplatz, directly above the archeological site of a medieval synagogue.

How did you get involved in the project, and what was on your mind as you created the piece?

Opposite left: Bruce Nauman, *A Cast of the Space under My Chair*, 1965–68. Concrete, 44.5 x 39.1 x 37.1 cm. Collection Geertjan Visser. Opposite right: Rachel Whiteread, *Untitled (One Hundred Spaces)*, 1995. Resin, 100 units, size according to installation. The Saatchi Gallery, London. Installation view: Carnegie Museum of Art, Pittsburgh, 1995. Above: Rachel Whiteread, *Untitled (Cast Iron Floor)* [detail], 2001. Cast iron and black patina, 99 units, 1 x 46 x 46 cm each; 1 x 502 x 411 cm overall. Collection of the artist and Luhring Augustine Gallery, New York

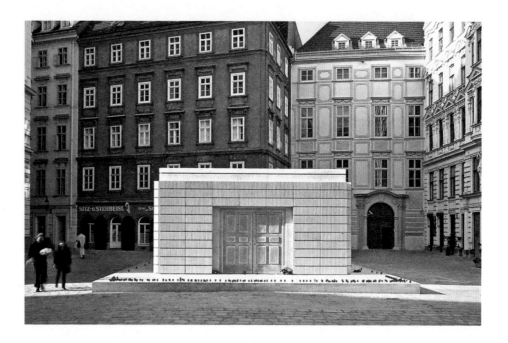

RW: When I came back from Berlin, I was asked to make a proposal for the Holocaust Memorial in Vienna. I had never been to Austria, and I looked at this project, and thought, very innocently, that Vienna would be an equivalent to Berlin, and it would be an interesting place to try to make a memorial to such atrocities.

In Berlin, I did a lot of reading. I also went outside the city and visited some concentration camps and thought long and hard about what had happened and how people have dealt with the Holocaust. I was very interested in the psychology of that experience, and the repercussions of it within the city.

When I went to Vienna, I didn't realize that the politics would be so different from the politics in Berlin. And I didn't think for a moment that my proposal would actually be chosen.

CH: Why was that?

RW: There were twelve to fifteen international artists and architects who had been asked to submit proposals, and I was a baby compared to most of them. In the end, I was selected, which was a mixed blessing. It entailed five years of very, very difficult problems—with the city, the bureaucracy, and the politics. Luckily, I worked with some really great architects there; if it wasn't for them, I probably would have been crushed

by the whole experience and might have just given up. I can't say I enjoyed making the piece at all, though I'm very proud that it's there.

CH: In making the casts of books for the memorial, you did it differently than you have for most of your other book pieces. Instead of doing negative casts—showing the space around the books—you created positive casts. The leaves of the books protrude toward the viewer, and we end up seeing what appears to be a library from the outside. What is the significance of these positive casts?

RW: When I was making this piece, I was thinking about how it might be vandalized, how it could be used without being destroyed, and how it should be able to live with some dignity in the city. One of the things that concerned me about vandalism was Serra's *Intersection* [1992], which is outside of the Basel Stadttheater. The last time I saw it, it was completely covered with graffiti as high as arm's reach. Inside were condoms, needles, and urine. It was a pretty grim reaction to a piece of public artwork. I knew my piece was going to be a memorial, and I wasn't quite sure if it would be respected. So I made replaceable book pieces that are bolted from the inside, and a series of extra pieces to serve as replacements if necessary, in case there is some terrible graffiti.

CH: So the reason for creating positive casts was a means to overcome the threat of vandalism.

RW: They are also much easier to read as a series of books, and I didn't want to make something completely obscure. I mean, some people already think it's an abstract block that they can't really understand; others think it's an anonymous library. It also looks quite like a concrete bunker.

CH: The bunker is a means of protecting oneself. I see the piece as a metaphor for protection on many levels.

RW: I wanted to make the piece in such a way that all the leaves of the books were facing outward and the spines were facing inward, so that you would have no idea what the actual books were.

CH: Why did you want to hide the names and titles of the books?

RW: I don't think that looking at memorials should be easy. You know, it's about looking; it's about challenging; it's about thinking. Unless it does that, it doesn't work.

CH: The library you've created seems institutional. The books are all the same size, placed in neat, even rows, and they fill the walls side to side. They look systematized.

RW: The original books for the cast were made from wood, so they are completely systematized.

CH: So nothing was ever really "documented."

RW: No. There's nothing real about that piece at all, in a way. The doors were

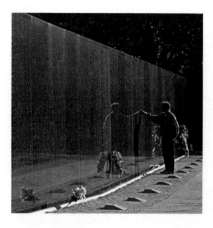

Opposite: Rachel Whiteread, *Holocaust Memorial*, Judenplatz, Vienna, 2000. Concrete, 3.8 x 7 x 10 m. Above: Maya Lin, *Vietnam Veterans Memorial*, Washington, D.C., 1982. Black granite, 150.42 m

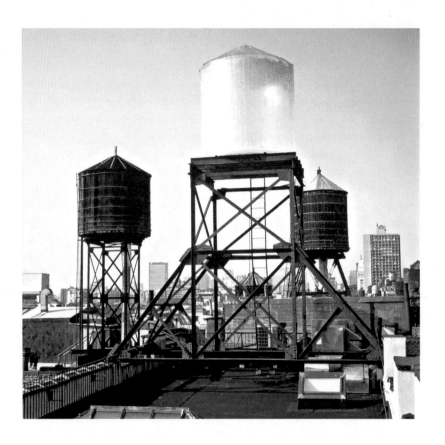

constructed; I constructed the ceiling rose. It's all about the idea of a place. Rather than an actual room, it's based on the idea of a room in one of the surrounding buildings. It was about standing in a domestic square amidst very grand buildings, and thinking about what the scale of a room might be in one of those buildings. I didn't ever want to try to cast an existing building.

CH: Other art and architectural projects related to the Holocaust were created at the same time as yours. Does your piece relate to Micha Ullman's *Bibliothek* [1996], a memorial against Nazi book burnings in Berlin? Or Daniel Libeskind's Jewish Museum [1997] in Berlin?

RW: No. If anything, my piece is a reaction against Alfred Hrdlicka's *Monument against War and Fascism* [1988], by the Opera in Vienna. It's a statue made out of granite and marble, consisting of screaming figures wearing gas masks. On the

ground nearby, there's a bronze Expressionistic lump, which is a Jewish man on his knees scrubbing the streets. People used to come by and use this particular piece of sculpture as a seat, or as a picnic stand. It was just unbelievable. Eventually, bronzed barbed wire was wrapped over the top of it.

In terms of other works, I actually think the memorial has far more in common with Maya Lin's *Vietnam Veterans Memorial* in Washington, D.C. When I was thinking about making the Holocaust memorial, I spent a week there, and visited Lin's memorial twice. I wasn't interested in the politics related to the monument, but the way people who are alive today respond to it, reacting to something that may be within their history or within their own family's history. Lin's piece showed incredible sensitivity and maturity.

When I visited concentration camps, I was more interested in how people responded to the camps than to the actual places. I spent a lot of time just watching people. I watched kids picnicking on the ovens, and other people stricken with grief. I saw grandparents with their grandchildren, having the most appalling experiences, trying to somehow tell this younger generation about the past.

CH: So now that the memorial is completed, how has it been received?

RW: I'm very surprised. It's actually very moving how people have reacted to it. I had expected graffiti, but people have been leaving candles, stones, and flowers on the memorial. I think it's already become a "place of pilgrimage." People come into the city and go to Judenplatz specifically to see the memorial, the museum in Misrachi Haus, and the excavations of the medieval synagogue underneath the square. If I've in any way touched people, or affected a certain political force in Austria, I'm very proud to have done that.

CH: During the time you were working on the memorial, you also created *Water Tower* [1998], a public project in New York commissioned by the Public Art Fund.

RW: Yes. I was asked to come to New York City and think about making a piece there. The sites I was initially offered were all very public, which didn't appeal to me. I really didn't want to get involved with that kind of scrutiny again so soon after *House*. I was much more interested in trying to do something that was sort of interactive with the city.

CH: From its site on top of a building in SoHo, the piece definitely interacted with the skyline. And it interacted with the city in another way too: I felt like you were commemorating a symbol of New York that we New Yorkers don't always notice, and this was accentuated by your choice of translucent polyester resin for the work. During the course of the day, the piece would appear and disappear depending on the effects of light in the sky.

In June of this year, you will unveil a new public project in London.

RW: After *House*, I thought I would never make another public piece in England again. The person who asked me to create *Monument* was the same one who commissioned *House*, James Lingwood from Artangel. At first I said, "You've got to be joking." But then I spent a day in Trafalgar Square as a tourist and just watched the people and the pigeons there, and thought to myself: "This is actually quite an extraordinary place. It's a massive roundabout with noise and a continuous tension between people and traffic. But then in the middle of it all is Nelson's Column, which makes you look up and see the sky, and the sky is peaceful." I wanted to help make a pause within Trafalgar Square—a place where your eyes could rest.

CH: *Monument* is translucent, like *Water Tower*. Are they made from the same material?

RW: Actually, they're not the same material, but they are similar. *Monument* will be the largest plastic casting ever made. It's been an ongoing investigation for three years. All the research from making *Water Tower* in New York went into creating *Monument*, but the engineering and the technology involved with *Monument* are substantially greater.

CH: How has your work transformed over time, from, say, *Ghost* and the furniture pieces to *Apartment* and *Basement*?

RW: Maybe the work has become a little tougher since *Ghost* . . . in terms of not giving so much away. I once said that I was removing Granny's fingerprints, making the work less sentimental. Over time I think I've removed them a little bit more. But I think a lot of the works that I've been making over the years have been part of a cyclical process. I could probably plot a family tree of these works. Things have happened, things branch off, things crop up that I haven't thought about. I often feel a cycle is incomplete and need to tread the same path again. That's just how I work. I've been teaching myself a language for the past fifteen years, and the utilization of that language can take on many forms.

This interview took place in Rachel Whiteread's London studio on April 18, 2001.

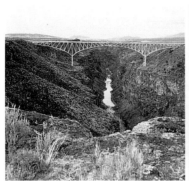

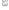

Photo Essay
Rachel Whiteread

65

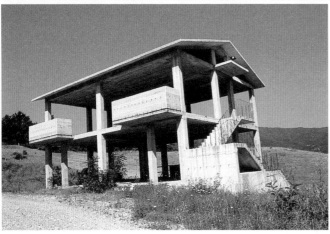
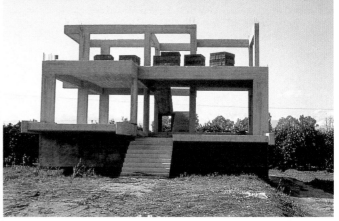

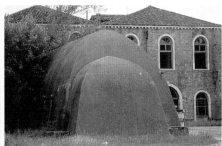

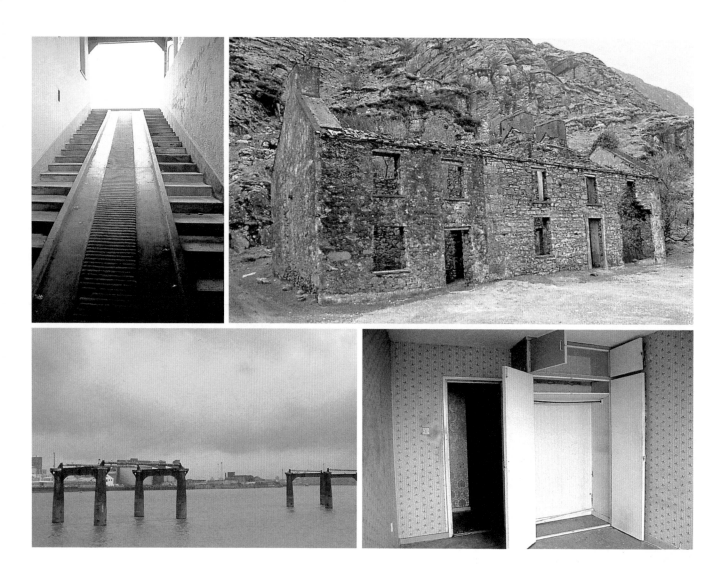

If Rachel Whiteread could cast herself, A. M. Homes once wrote of her, she would pour liquid plaster or resin down her throat until her insides are completely filled, wait until it set, and then peel herself away.[1] "But of course, I wouldn't," Whiteread said when we met in London last spring, laughing as if she nevertheless liked the idea. In fact, this is precisely what she has been doing in her work: casting herself, her body, her memories, her pains.

First, in a kind of warm-up exercise while still a student at the Slade School of Art, she literally cast parts of her own body. Not just an arm or a foot, but an elbow or the two fragments of a leg articulated at an angle by the knee—she told me while embracing these parts of her body with her arms to demonstrate. A body abstracted then, a body treated like a piece of furniture, a set of joints. "That kind of direct relationship stopped in 1987." Not surprisingly, her next move was to cast furniture. Not a table, a bed, a sink, a bathtub, or a cupboard as such (what Whiteread has called the "furniture of our lives"),[2] but the space trapped by these familiar objects. Unlike the casts of body parts, many of these pieces are negative casts. Space not as a container, but as the contained, the solid volume of the air defined by these objects: A three-dimensional figure/ground map of the props of our domestic scenes, or a photographic negative in three dimensions of these objects, their imprint on the space of the room. Or is it the imprint of the body in this furniture? It is as if Whiteread plays with the sense that furniture is already a cast of the body. She is casting a cast. "The first table I made in 1989 was to do with exchanging one's personal space with that of that table, the physicality of how you sit when you have a table in front of you, how your legs behave, etc."[3] The casts themselves become bodies. Of her black rubber piece, cast from the underside of a bed, she says it has "this lip, like a clitoris."[4] And the concave-convex beds she describes as "bodies in spasm."[5] Making casts out of furniture, she says, "was at first, an autobiographical impulse, using something familiar, to do with my childhood."[6] She began by casting the space inside a wardrobe—not her own, but a wardrobe reminiscent of one she used to hide in as a child (*Closet*, 1988). Then the space under a bed—never her bed, much less the bed in which she was born, as some critics have suggested, but nevertheless it was not unlike others she had known—became a piece completed two months after the death of her father (*Shallow Breath*, 1988).

Whiteread wanted to see the space entrapped by furniture, to make it solid, palpable, until she became dissatisfied with those exercises because "furniture is too much like people." Looking for a displacement, for something less literal, she turned to architecture: The space under a bed gave way to the volume of air contained inside the four walls of a room in a derelict Victorian house in North London (*Ghost*,

I Dreamt I Was a Wall
Beatriz Colomina

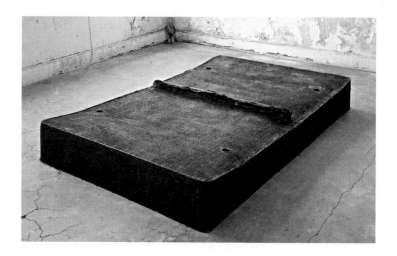

1990) and, later, the air inside a condemned terraced house in East London (*House*, 1993). The intention of *Ghost* was "to mummify the sense of silence in a room, to create a mausoleum of my past and also something to which others could relate—like the room in the Victorian house where I was born."[7] Whiteread repeatedly uses the image of mummification when talking about her more architectural pieces.[8] Having turned from furniture to architecture for a less literal connection to the body, the body reappears, but mummified, preserved for the afterlife by being tightly wrapped with layers of linen and resin that have precisely the shape of the body they enclose—a kind of cast—a body suspended between life and death, the physical and the nonphysical. But to be precise, what she mummifies is the air in the room. The air treated as a body.

If furniture is too much like a body, so then is architecture, but it is not simply a physical body. Casting a space is like interviewing it, asking it to tell its story. Not by chance, Whiteread asked the writer Tony Parker, who spoke with convicted murderers for two of his books, to "interview" *House*. She wanted Parker to draw a story out of the house; he declined. "He must have thought that I was mad,"[9] she says. In fact, Whiteread was asking him to do what she already does herself. Casting a space is to reveal its secrets, to show the unseen. This is in no way a polite affair. She is not gently coaxing a story out of the space, prompting it to speak as if she were not even there. Casting is an interrogation of space: violently pulling evidence out of it, torturing it, forcing a confession. If anything, casting approaches the supposedly benign but actually brutal techniques of medical inquiry and diagnosis, and the no less

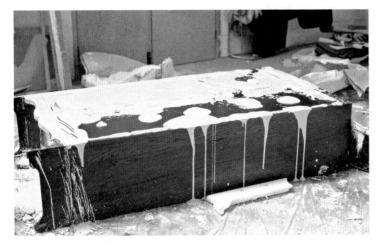

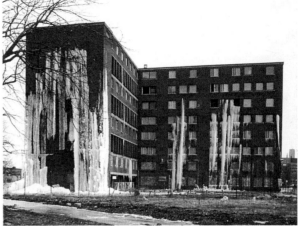

violent excavations and demolitions involved in psychoanalysis. If Whiteread is interested in the body, then, it is not just any body. It is the medical body, the pathological twentieth-century body constructed by medical science and the traumatized body of what may be the most horrific century in history, the body in need of therapy.

Whiteread's casts are on the one hand suggestive of traditional forms of medicine, such as the repair of broken bones (*Ghost*, she says, was like a "plaster cast": "covering the room in plaster, inch by inch, building it up and securing it with scrim . . . was like covering a broken limb")[10] and of ancient forms of studying anatomy: the anatomical models based on dissections performed in the Renaissance. Bodies turned inside out are displayed today to the fascination of many contemporary artists and cultural theorists in natural history museums like La Specola in Florence. Art, architecture, and medicine have always been inextricably linked. When Whiteread was at the Slade, which is part of the University College of London, where there is also a medical school, she says she got to know one of the technicians who would show her brain specimens.[11] Leonardo and Michelangelo engaged extensively in dissection and Leonardo built a neuroanatomic model of the brain by injecting wax into the ventricular system of the brain, forming a cast that was then dissected from the surrounding tissue.[12] The now famous claim made by an enraged neighbor of *House* and reported in the newspapers at the time of the uproar over the piece, "If that is art then I'm Leonardo da Vinci!"[13] acquires a new meaning.

In fact, the difficulty of finding bodies to be cast in the Middle Ages and the Renaissance, when the impediments of the church and general public opposition to

Opposite: Rachel Whiteread, *Untitled (Black Bed)*, 1991. Fiberglass and rubber, 30.5 x 188 x 137.2 cm. Irish Museum of Modern Art, on loan from Weltkunst Foundation, Dublin. Above left: Rachel Whiteread, *Closet* (in process), 1988. Above right: Camilo José Vergara, 1995 photograph of abandoned building (Henry Horner Houses, Chicago) in which pipes burst and water pouring from windows froze

1. A. M. Homes, "The Presence of Absence," in *Rachel Whiteread*, exh. cat. (London: Anthony d'Offay Gallery, 1998), p. 35.
2. Rachel Whiteread, quoted in C. Carr, "Going Up in Public," *The Village Voice*, June 23, 1998, p. 72.
3. "Rachel Whiteread Interviewed by Andrea Rose," in Ann Gallagher, ed., *Rachel Whiteread: British Pavilion, 47th Venice Biennale*, exh. cat. (London: British Arts Council, 1997), p. 30.
4. "I tried to make the lip in such a way that I had no control over it so I stuffed rubber into the mold which had bits of plaster, hair and other materials attached to it and which I left on the piece." Quoted in "Rachel Whiteread in Conversation with Iwona Blazwick," *Rachel Whiteread*, exh. cat. (Eindhoven: Stedelijk van

dissections meant seeking the scarce bodies of convicted criminals, finds its equivalent in the trouble Whiteread has locating spaces that she can cast. The search for a condemned dwelling for *House* is supposed to have lasted over two years. With the amount of demolition going on in London in the 1990s one would have thought it might have been easier. (The condemned houses that Gordon Matta-Clark used for his projects in New Jersey were also difficult to find. It was through his gallerist, Horace Solomon, who happened to also be a real-estate investor, that he was able to secure the use of the house that became *Splitting* [1974]. Matta-Clark received a number of angry letters about his project, one of which accused him of performing an "out and out rape" on the house.)[14] *House* touched a nerve in London, as if the old place was a body whose memory should be respected, and the public outrage it caused speaks of a resistance not unlike that of medieval people to the casting of corpses. It was the wrath of those living in similar houses that became explosive. They felt themselves exposed, as if they had been asked to stand naked outside, or worse, as if their insides had been made visible. They wanted *House* demolished, bulldozed away, buried.

Buildings are bodies for Whiteread, but not the idealized, healthy, virile, upright bodies, which, following Vitruvius, served as blueprints for architectural proportions in the Renaissance architectural treatises of Alberti, Francesco Di Giorgio, Filarete, Cesare Cesariano, and so on, or the body that perhaps may be regarded as its contemporary equivalent: the trim, muscular, overly exercised body of our time. Whiteread's body is the pathological body of late-twentieth-century medicine, the one subjected to ever more invasive and violent procedures, whose inside needs to be seen in greater detail in order to monitor it, to diagnose it, to intervene in it. A body fragmented by clinical scrutiny. A body that above all is an interior. A body turned inside out for inspection. Not by chance does Whiteread speak of her desire for the viewer of her first floor piece (done for the Fridericianum at Documenta in 1992) to become "like a microscope."[15]

Just as schools of medicine used casts of body parts, schools of architecture used cast fragments of historical buildings for teaching, and the same conventions for representing the body's interior were used to represent the interiors of buildings. In Leonardo's work, cutaway views of architectural interiors even appear on the same page as anatomical drawings.[16] Eugène-Emmanuel Viollet-le-Duc likewise illustrated his *Dictionnaire raisonné de l'architecture française du XIe au XVIe siècle* (1854–68) with perspectival sectional drawings showing medieval buildings as if dissected. In his preface to the first volume, Viollet, who was influenced by George Cuvier's *Léçons d'anatomie comparée* (1800–05), called for a study of medieval architecture as the study of an "animate being," involving the "dissection" to allow

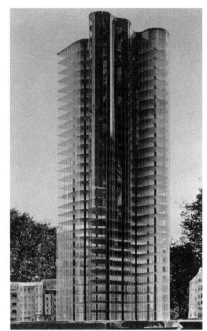

separate study of its parts. He developed a new mode of drawing to show the functional role of each dissected fragment.[17]

It is not just that architecture has been represented through the centuries as if it was a medical body, the whole conception of the building shifts with each new medical advance. The impact of X-ray technology is evident in the work of many architects of the early decades of the twentieth century. Mies van der Rohe, for example, not only called his work "skin and bones" architecture but represented his buildings as if seen through an X-ray machine.[18] Likewise, in recent years it may be said that contemporary architects have responded to the latest technologies in medical diagnosis and representation. The CAT scan may be for us what the X ray was for modern architects. Today, a new generation of architects is producing experimental work under the influence of computer-assisted technologies that allow complete three-dimensional modeling of the inside of the body. The Yokohama International Port Terminal in Japan designed by Foreign Office Architects (begun in 1995), for example, is represented as a series of sectional cuts resembling a CAT scan, and the building itself shares the continuous logic of the scan.

**Opposite: Luigi Calamai, anatomical model of young man's torso, ca. 1829. La Specola, Florence.
Above left: Drawing of the correspondence between the human body and the plan of a church, from Francesco di Giorgio Martini, *Trattati di Architettura Ingegneria e Arte Militare*, ca. 1482.
Above right: Ludwig Mies van der Rohe, model for *Glass Skyscraper*, Berlin, 1922 (destroyed)**

Abbemuseum, 1993), p. 8.
5. Rachel Whiteread, interviewed by Craig Houser, London, April 18, 2001.
6. "Rachel Whiteread in Conversation with Iwona Blazwick," p. 8. In another context the artist states, "I don't play with the unfamiliar. I work with things that are somehow connected with me." Quoted in C. Carr, "Going Up in Public," p. 72.

Like bodies, buildings are vulnerable to every known medical problem and therefore must be controlled. If a building is healthy, modern architects believed, it would enhance the health of those who occupy it. Architecture was understood as a health-inducing instrument, a kind of medical equipment for protecting and enhancing the body. A building was a living, breathing organism, with skeleton, limbs, nerves, skin, organs, etc. "The house," Frederick Kiesler wrote, "is a living organism with the reactivity of a full-blooded creature," with organs (the stairs are the feet, the ventilation system is the nose, and so on), a nervous system, and a digestive system that can "suffer from constipation."[19] Whiteread too speaks of buildings breathing. But if the call for ventilation and clean air by modern architects was an optimistic appeal for an architecture able to produce a healthy body, devoid of tuberculosis,[20] the dominant medical obsession of that time, for Whiteread the reference to breathing buildings quickly turns into a bleak excursion into the late-twentieth-century illnesses of the buildings themselves: sick building syndrome (allergy and diseases transmitted through air conditioners, building materials, contaminated water, gases, etc.). Modern buildings, once identified with the healthy body, turn on their occupants, literally rendering them unhealthy.

> There are offices in London that are out of commission because they have sick building syndrome. It's as if we are building these mausoleums for ourselves. We don't know how to deal with these buildings that are almost living and breathing, they have their own viruses: Legionnaire's Disease is transmitted through air-conditioning systems. They are almost organic—you go into a building and it hums—it is the computer lines, the lights, the heating—this noise which sweeps into it.[21]

Whiteread talks about buildings that not only breathe, hum, lose fluids, and get sick, but have "skeletons," "intestines," "nerves," "a bladder," "blood vessels," "tear ducts": "I think of houses in terms of skeletons, the plumbing and electricity as nerves and blood vessels. . . . The water tower might be the bladder. Or perhaps the tear ducts."[22] And these hidden systems harbor the secrets she seeks. The space beneath the floorboards, she says, is "like the intestines of a house, containing the vestiges of the lives of those who had lived there."[23] This is the invisible body, the body invoked in common language only when its mechanics are malfunctioning, the internal body parts that we get to know intimately, look at in diagrams in medical books, scrutinize via sonogram images and X-rays, only when they are under suspicion. The invisible parts that, in a way, become solid and detached from the rest of the body when in trouble, as with those votives in the form of models of body parts that are offered since the Middle Ages to saints and virgins in the hope of curing or preserving an organ, or a body part. Originally made of wax (or terra-cotta for the poor, silver for the rich) casts

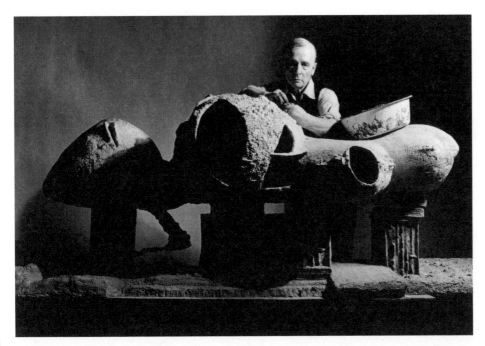

Above: Frederick Kiesler with model of *Endless House*, New York, 1959. Photograph by Irving Penn

of hearts, kidneys, bladders, eyes, ears, lungs, breasts, testicles, a uterus, ovaries, brains, and so on, still line the walls of many sanctuaries across Europe. In fact, it is this ritualistic, rather than scientific, function that is at the origin of the earliest forms of casting. The first wax models of bodies made were the death masks used in funerary rites in ancient Greece (ca. 300 B.C.) and the wax models of body parts, for which healing was hoped, offered to deities.[24]

The similarity between making her work and casting a death mask is not lost on Whiteread, who speaks of her discomfort with the lingering relationship to the inhabitants of the house used to cast *House* because she had already made their death mask: "When I made *House*, I met the previous occupants and we kept in touch for a while. But actually, it made me feel a little bit uncomfortable. It was like I'd cast their history. I didn't want to intrude in that way."[25] She understood the careful documentation of the insides of their house before it was cast as a form of dissection and an embalming of the body, a process recalling that used in the direct modeling of the almost obscenely opened bodies at La Specola.

The previous tenants were obviously DIY fanatics. The house was full of fitted

7. Whiteread, quoted in Iain Hale and Dalya Alberge, "Youth and Beauty?" *The Independent* (London), July 16, 1991, p. 17.

8. The artist says, for example, "I wanted to incarcerate the silence in a room, mummify the air inside the four walls." Whiteread, quoted in Mrieke van Giersbergen, "The Ghost of Memory," *Archis* 2 (Feb. 1993), p. 9.

9. Whiteread, in conversation with the author, London, May 30, 2001. The books by Parker that Whiteread mentioned are *Life after Life: Interviews with Twelve Murderers* (London: Secker & Warburg, 1990), and *The Violence in Our Lives: Interviews with Life-Sentence Prisoners in America* (London: Harper Collins, 1995).

10. "Rachel Whiteread in

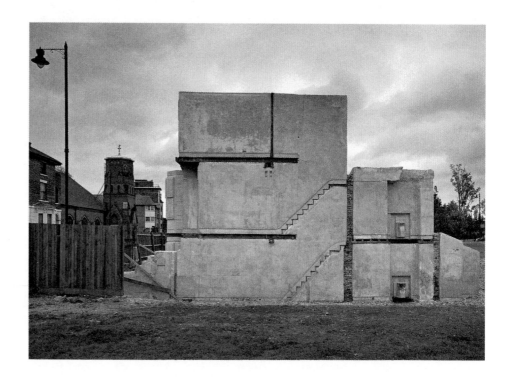

cupboards, cocktail bars and a tremendous variety of wallpapers and floor finishes. I was fascinated by their personal environment and documented it all before I destroyed it. It was like exploring the inside of a body, removing its vital organs. I'd made floor pieces before in the studio and had always seen them as being like the intestines of a house, the hidden spaces that are generally inaccessible. We spent about six weeks working on the interior of the house, filling cracks and getting it ready for casting. It was as if we were embalming the body.[26]

This embalming of the house before casting it, like the preparation of an Egyptian mummy, is another form of casting, in which the shape and details of the body are preserved. This double casting is crucial to Whiteread's work. Indeed, if anything, the real cast is the first embalming one. What is shown in galleries and publications is not the cast of an object, or even the cast of the space around an object, but the cast of a cast. All of Whiteread's artistry lies in her decisions about the first cast, what traces will remain and what will disappear, the same crucial decisions faced by the maker of a death mask.

Even Whiteread's working method parallels that involved in the making of a death mask, as can be seen in the following description of that process by Georg Kolbe. He begins by preparing all surfaces and closing all apertures, just as Whiteread starts by sealing off the windows and doors. Kolbe writes:

> *The eyelids and lips are gently closed, the chin is propped. . . . The hair is combed smooth. . . . Taking the mask is not, or should not be, making a mold from a rigid body— it almost resembles modeling from life. . . . The parts where hair is growing are painted over with a thin solution of modeling clay or with oil, so that the plaster may not adhere when it is poured over. The skin itself contains enough fat and needs no preparation. The outline of the mask, the parts on the neck, behind the ears, and so on, are surrounded with the thinnest of damp paper. Unfortunately there is hardly ever time to mold the whole head, back and front; relatives and friends and undertakers are waiting, and the work must be done speedily, as always in our precious life. A large bowl of plaster the consistency of soup is ladled over the face a few millimeters in thickness; then a thread is drawn over the middle of the forehead, the bridge of the nose, the mouth, and chin. A second bowl of more solid plaster is spread over the first layer like pulp (this is to provide a firmer outer shell), and before it sets the thread is drawn away, dividing the whole in two halves. As soon as the outer layer has set hard, the halved mold is broken apart and carefully detached from the head. . . . The halves thus detached are immediately fitted together again and clamped, the negative is cleaned and refilled with plaster. Roughnesses on the covering outer shell are carefully chipped away with mallet and chisel, and there we have the positive, the finished mask. I do not touch it again, for it must be good.* [27]

The result of this process is a line down the middle of the mask, a scar where the two molded halves are reattached. Similar lines can be seen everywhere in Whiteread's work (for example, in the sink and bathtub pieces). But the brick that shows in rough narrow bands in *House*, indicating where there was a wall between two rooms, a floor, or a staircase, are seen by Whiteread as a kind of failure—the "scars"[28] of that piece—as if the casting of *House* and its separation from the mold was a brutal act, with fragments of the old place left behind like battle scars when all she wanted to show was the air, the negative of the space, a three-dimensional figure-ground of the body of the house, perhaps not unlike a three-dimensional X ray.

The basic procedure of casting recalls the "barium swallow" in medicine, used for the examination of internal organs with X rays. The patient drinks a chalklike liquid to cover the interior lining of the esophagus, stomach, and intestines, allowing their outlines to be seen by the X-ray machine and reveal any blockage or inflammation. The chalky liquid hardens like plaster in the system and has to be flushed out after the

Conversation with Iwona Blazwick," p. 14.

11. Whiteread, in conversation with the author.

12. Joseph C. T. Chen, et al., "The Development of Anatomic Art and Sciences: The *Ceroplastica* Anatomy Models of La Specola," *Neurosurgery* 45, no. 4 (Oct. 1999), p. 884.

13. *East London Advertiser*, Nov. 4, 1993. Reprinted in Iain Sinclair, "The House in the Park: A Psychogeographical Response," in James Lingwood, ed., *Rachel Whiteread: House*, (London: Phaidon Press, 1995), p. 22, and extensively quoted in criticism of the piece.

14. Pamela M. Lee, *Object To Be Destroyed: The Work of Gordon Matta-Clark* (Cambridge, Mass.: MIT Press, 2000), p. 21.

15. "Rachel Whiteread Interviewed by Andrea Rose," p. 32.

16. Scott Drake, "Anatomy Architecture," transcript of paper presented at SAHANZ (Society of Architectural Historians of Australia and New Zealand) Conference, held in Launceston and Hobart, Australia, 1999, p. 53.

17. See Barry Bergdoll, "*The Dictionnaire raisonné*: Viollet-le-Duc's Encyclopedic Structure for Architecture," Introduction to Eugène-Emmanuel Viollet-le-Duc, *The Foundations of Architecture: Selections from the Dictionnaire raisonné* (New York: George Braziller, 1990).

18. Beatriz Colomina, "X-Ray Architecture," paper presented at the Society of Architectural Historians, Houston, April 1999. Also forthcoming in Thomas Y. Levin, ed., *CTRL [SPACE]: Rhetorics of Surveillance from Bentham to Big Brother*, exh. cat. (Karlsruhe: Center for Art and Media; Cambridge, Mass.: MIT Press, 2001).

19. "A house must be practical. To be practical means to serve. To be serviceable in every respect. In any direction. If any directions are closed, the house suffers from constipation." Quoted in Kiesler,

examination. An old medical procedure, practiced since the beginning of the last century and still in use as a first tool of detection because it is considered simpler and less invasive than more contemporary techniques, is in fact, quite invasive and violent.

Whiteread's castings are just as invasive. For *House*, the space first had to be completely altered:

> *[and] stripped of secondary trappings and cleaned up to provide a smooth finish throughout to which the concrete would be bonded. Windows were filled with plywood to insure that the spraying did not merely blast the glass out through the frame. All the reentrant corners and recesses were infilled to insure that when lifted away the external skin would not pull elements of concrete with it. The walls were coated with several layers of a debonding agent. . . . Reinforcing mesh was fixed to the walls where the concrete was to be sprayed. . . . The concrete was then sprayed onto the mesh in consecutive layers, over several weeks. A small opening in the roof was left for the last worker's exit from the fully sprayed interior.*[29]

After ten days the concrete had cured and scaffolding was placed around the house to allow the removal of the original building. The operation resembled a slow demolition, or at least a radical renovation. The production area of the artwork looked like a construction site with scaffolding, people wearing hard hats and work clothes, holding tools. There is the dust, noise, and smells of construction everywhere. Drawings had to be done, engineers consulted, construction workers recruited, permits from the building department obtained, etc. It was a project. A cast is not simply taken. It is designed. And the design is at once architectural and medical.

In her studio, Whiteread has an image of a preserved body. You see the sinews and bones of the Glacier Man, a body about 5,000 years old: "As a child I saw a book on the 'Bog People.' They were preserved in dense peat and their faces looked like they were made of graphite. I'm always intrigued by information such as the fact that it takes longer for a body to decompose today than in Victorian times because all the preservatives we've consumed."[30] Whiteread is fascinated by bodies somehow suspended between decomposition and preservation, bodies disintegrating and being reconstructed with sophisticated technologies. Medical attempts to save the body somehow resonate with the techniques used to keep it intact after death. Her castings suggest the twentieth-century pathological body, the body subjected to increasingly invasive procedures, the body that needs to be seen inside in ever greater detail in order to diagnose it. The inside of the body first brought to us with X-ray images, and barium swallows, then laparoscopy, computer tomography (CT scans), magnetic resonance imaging (MRI), ultrasound, Doppler ultrasound, and so on. Even the colors of Whiteread's pieces are taken from those of our insides. She aims for the "color of

semen," or makes a request from a manufacturer for rubber that is "the color of urine"—more precisely, "a dark yellow, the color of the first piss in the morning."[31] She speaks of the "sweat and urine" stains in the mattresses she has used, and of how you "may get a piss stain in your face" when moving them, but "feels it's necessary to manhandle this stuff,"[32] to engage fully in the usually repressed traces of the body. Again, this is an internal story, a private affair, but also the stuff of medical diagnoses.

And of police evidence. Casting is taking the "fingerprints" of a space. In Munich, the Haus der Kunst was relocating. Whiteread cast the floor of the existing museum to be displayed in the renovated space, as if "taking a fingerprint from the old place and putting it into the new one."[33] All the analysis that goes on prior to casting is a kind of detective work, scrutinizing all the traces and deciding which of them should be exposed, as if selecting the key pieces of evidence. Like taking a plaster cast of a footprint or drawing a chalk line around a corpse, Whiteread concentrates on the overlooked details of seemingly ordinary things in order to determine what has gone on in the space. Every object she casts is treated as a crime scene. Every object has dark secrets hidden within its surfaces. She works with traces, patiently studying, recording, and eventually monumentalizing them.

Because it is not just the hidden mechanics of the body that interest Whiteread. She also wants to know what goes on inside a mind, how the mind works. And again, not just any mind. Like the writer Tony Parker, she is fascinated by the pathological psyche. And if, as she did for *House*, Whiteread were to ask Parker to interview her new home, a former synagogue that she recently acquired, it would not be because she might expect it to have a dark secret that could be extricated. Whiteread is endlessly curious about human nature, what makes people lose their minds, commit horrendous crimes: "Obsessive or compulsive disorders, completely irrational activities, the psychology of violence—I find these things fascinating. What makes an individual lose control and kill sixty people. It's a dark area of human unconsciousness that no one can unlock, something we will never fully understand."[34] She looks for evidence of this in the overlooked ordinary spaces of everyday life, in the same way that Parker brings us evidence of the ordinariness of many convicted murderers in the stories of the circumstances that preceded their crimes, the mundane details of their life before and after their acts, as told by the perpetrators themselves.

For Whiteread, objects are interesting in as much as they give clues about the lives and deaths they witnessed. She tells the story of how she once almost visited 25 Cromwell Street in Gloucester, the address of Fred and Rosemary West, the couple who murdered eighteen young women in their house and buried the dismembered bodies beneath a bathroom, under a kitchen, in the cellar, and in the garden. A friend of the

"Pseudo-Functionalism in Modern Architecture," *Partisan Review* 16, no. 7 (July 1949), p. 739.
20. Beatriz Colomina, "The Medical Body in Modern Architecture," in Cynthia Davidson, ed., *Anybody* (Cambridge, Mass.: MIT Press, 1997), and "Krankheit als Metapher in der modernen Architektur," *Daidalos* 64 (1997).
21. "Rachel Whiteread in Conversation with Iwona Blazwick," p. 12.
22. Whiteread, quoted in Darcy Cosper, "Casting New York: Rachel Whiteread's *Water Tower*," *Metropolis* 17, no. 9 (June 1998), p. 109.
23. "Rachel Whiteread Interviewed by Andrea Rose," p. 34.
24. Chen, et al., "The Development of Anatomic Art and Sciences: The *Ceroplastica* Anatomy Models of La Specola," p. 884.
25. Whiteread, interviewed by Craig Houser.
26. "Rachel Whiteread Interviewed by Andrea Rose," p. 33.
27. Georg Kolbe, "How Death Masks are Taken," in Ernst Benkard, ed., *Undying Faces: A Collection of Death Masks*, trans. Margaret M. Green (New York: Norton, 1929), pp. 44–45.
28. Whiteread, in conversation with the author.
29. Neil Thomas, "The Making of House: Technical Notes," in *Rachel Whiteread: House*, p. 130.
30. "Rachel Whiteread in Conversation with Iwona Blazwick," p. 14.
31. "Rachel Whiteread Interviewed by Andrea Rose," p. 33.
32. "Rachel Whiteread in Conversation with Iwona Blazwick," p. 13.
33. Whiteread, interviewed by Craig Houser.
34. "Rachel Whiteread in Conversation with Iwona Blazwick," pp. 14–15.
35. "Rachel Whiteread Interviewed by Andrea Rose," p. 34.
36. Whiteread, in conversation with the author.
37. Whiteread, interviewed by Craig Houser.
38. "Rachel Whiteread Interviewed by Andrea Rose," p. 30.
39. "Rachel Whiteread in Conversation with Iwona Blazwick," pp. 12–13.
40. Ibid.

artist was writing a book about the case and invited her over to see the house: "From television coverage there was the suggestion that it bore a relationship to *House*. While I was deliberating whether to go or not, I dreamt that I was a wall in the house, like the image in Roman Polanski's *Repulsion* (1965). I dreamt I witnessed the horrific events of the past fifteen years. I woke up screaming and decided not to go."[35] She dreamed she was a wall, a witness. She says she is still glad she didn't see the house because she would have had to live with those images all her life.[36] It is as if seeing the site where the murders took place would have amounted to watching the murders themselves.

Whiteread is captivated by the traumatized mind. As if performing a medical diagnosis, she moves from mapping the internal body (casting interiors) to reading its external signs (observing people's reactions to spaces of trauma). When she lived in Berlin for a year, she spent a lot of time at the sites of the concentration camps "people-watching," observing how visitors responded to the environment: "I watched kids picnicking on the ovens, and other people stricken with grief. I saw grandparents with their grandchildren, having the most appalling experiences, trying to somehow tell this younger generation about the past."[37] Once again, the issue is not the form of the camps as such but the behavior of people in relation to these spaces and their traumatic memories that intrigues Whiteread.

Her work aims to provoke disturbing psychological states, such as claustrophobia and disorientation. Space pathologies. With her first table piece, for example, she says she was trying to make it a "claustrophobic space,"[38] a feeling that is also present in many other works. Sometimes the effect turns out to be unbearable even for her. "With the third bath piece, I drilled holes through the plaster and the glass on top of it so there was an airflow like nostrils. I felt that it was too claustrophobic, like suggesting my own death."[39] And about a closet piece she says, "A long time ago I made a work with a wardrobe which I turned on its side in the studio. I had it propped on a bentwood chair and a pillow, with the door open—it was like a trap—I made it and photographed it and then dismantled it because it made me terribly uneasy."[40] Sometimes these disturbing, unexpected effects are precisely the triumph of a piece, as in the disorientation produced by *Ghost*:

> With Ghost, *my first architectural piece, I wasn't really aware of everything I was doing while I was making it. It was very complicated to make. I would finish a panel, look at it, put it back on the wall, make another one. . . . I never really saw it until it was finished. Then I took it to the studio to make a framework for it. And one morning after a week or two, I opened the door of the studio, and there was the door of* Ghost *with the light switch, and the light switch was going the other way and I realized 'I am the wall.'*[41]

The complication of making architecture means that a work can never be completely

visualized before it is actually built, something that architects have always had to deal with—especially those who think of space in sculptural terms. Adolf Loos, for example, was unable to make decisions about a space before it was actually under construction and "prided himself on being an architect without a pencil."[42] Likewise, Whiteread is reluctant to install an exhibition "on paper," preferring to make decisions in the gallery.[43] Engaging for the first time with architecture in *Ghost*, Whiteread was suddenly thrown into the position of a first-time viewer of her work and could see that the only position for that viewer is in the wall. The inverted light switch is that which the wall sees. To look at a Whiteread cast is not to be put in an architectural space or outside of it. Rather, it is to be placed in the wall, as a witness of the space, assuming for a moment the role of the wall.

Not by chance, Whiteread sees the significance of her last cast—the upstairs apartment of the old synagogue that she and her partner recently bought and plan to convert into a home and studio—in the fact that she was finally able to cast those walls as a space, creating a piece as a system of gaps that would look "like a maze." As she describes it, "with *Apartment* . . . we did an awful lot of casting for six months. . . . The engineering and crazy gymnastic backward thinking that was needed to make the piece was remarkable." She has also said, "in *House*, the gaps were all filled in with brick, but here, I've done a lot of casting to make a wall space. . . . The bit that was missing, that was me. I have now made it."[44]

Opposite: Rachel Whiteread, *Ghost* (det.), 1990. Plaster on steel frame, 269.2 x 355.6 x 317.5 cm. The Saatchi Gallery, London. Above: Ernst Neufert, from *Bau-Entwurfslehre*, 1936

41. Whiteread, in conversation with the author.
42. Richard Neutra, *Survival Through Design* (New York: Oxford University Press, 1954), p. 300. Loos devised the *Raumplan* as a means of conceptualizing space. As his assistant Kulka recalls, "He will make many changes during construction. He will walk through the space and say: 'I do not like the height of the ceiling, change it! The idea of the *Raumplan* made it difficult to finish a scheme before construction allowed the visualization of the space as it was." Quoted in Beatriz Colomina, *Privacy and Publicity: Modern Architecture as Mass Media* (Cambridge, Mass.: MIT Press, 1994), p. 269.
43. Whiteread, interviewed by Craig Houser.
44. Ibid.
45. Whiteread, in conversation with the author.
46. Whiteread, interviewed by

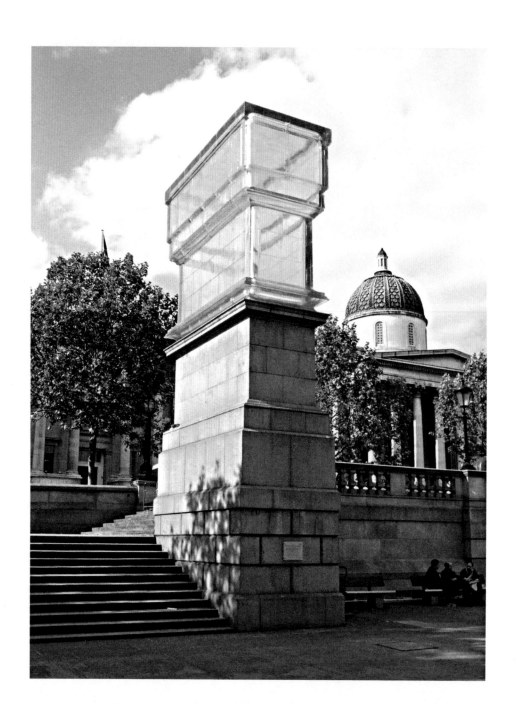

If Whiteread began by casting her own body, she has ended up casting herself as a gap, the space within a wall. This breakthrough came with a shift in working method. Unlike *House*, where the old building was used as a mold and then destroyed, the old synagogue had to stay. She describes the process: "First of all, I am in the room and I think about how things are going to be removed. Everything is based on the physical size of what you can take out of a door and down the staircase. . . . This is how I usually do things. It is always a question of what can be removed by me or one other person. It requires very careful planning."[45] Like planning the perfect murder, the first consideration is how to dispose of the body. To get it out of a house usually involves dismemberment. With *Apartment*, the casting was done in sections, imploded, in order to get it out of the room.

This calculation recalls the planning of a traditional house, where the size of a stair (actually called a "coffin stair") is determined by the space needed to take down a coffin carried by three pairs of men, and that of a door is that which allows the passing through of a coffin. The apartments Whiteread has recently cast, presumably built for the synagogue's rabbi and caretaker, are according to her, much like "archetypal council flats": "small rooms leading off a corridor, and usually the rooms are based on the proportions of an arm span."[46] Architecture not unlike the postwar architecture Whiteread is obsessed with and says is based on the "arm span" and the "leg stretch." Modern architecture, like its traditional counterpart and like Whiteread's casts, takes its dimensions from the body, whether living or dead. Her casts preserve the evidence of this body after the building has gone. In the case of the synagogue, both building and cast remain, but the possibility of the cast outliving the building is always there; it is a record, a document, "like taking photographs or making prints of the space. If those parts of the building don't exist later, I'll still have this archive of the place."[47]

Casting parts of her new building was also a way of "getting to know it intimately."[48] As in anatomical studies, getting to know an interior involves dissection. Whiteread points out that her new neighborhood, London's Whitechapel, was where Jack the Ripper used to kill his victims. The never-identified murderer performed such skilled mutilations of the bodies of his prey that he was presumed to be a surgeon with "considerable anatomical skill and knowledge," somebody "accustomed to the postmortem room," in the words of one coroner.[49] Inner organs, and even the content of the victim's pockets were carefully arranged by Jack the Ripper and displayed as a kind of gruesome artwork.

Whiteread's dissections focus on the walls. She says: "Internal walls are always ill conceived in architecture, in social housing. They are used to block one thing from another."[50] In *Apartment* she opens up the body of architecture in order to reveal the blockage. The viewer can peer into narrow spaces that retain the marks of light

Opposite: Rachel Whiteread, *Monument*, Trafalgar Square, London, 2001. Resin, 4.5 x 5.1 x 2.4 m

Craig Houser.
47. Ibid.
48. Whiteread, quoted in Rose Aidin, "A Sculptor Who Casts a Long Shadow," *Sunday Telegraph Review* (London), June 17, 2001, p. 5.
49. Coroner Wynne E. Baxter's summation of the case of the murder of Annie Chapman.
50. Whiteread, in conversation with the author.
51. Whiteread, interviewed by Craig Houser.
52. "Rachel Whiteread Interviewed by Andrea Rose," p. 32.
53. Lynn Barber, "Someday, My Plinth Will Come," *The Observer Magazine* (London), May 27, 2001, p. 35.
54. A photograph taken by Gautier Deblonde of the artist standing inside *Monument* was published in *The Independent Magazine* (London), May 26, 2001, p. 15.

I am grateful to Jeannie Kim for her research assistance.

switches, electrical plugs, and so on. That these traces are, once again, seen in terms of the body is evident in Whiteread's discussion of the ceiling, which has also been cast. The ceiling had a light fixture in the center that, she says, will now be "a kind of belly button" of the piece, visible when seen from above. Even though the viewer cannot see the marks on the walls made by the electrical plugs, switches, and fixtures, Whiteread thinks it is "incredibly important" that they are part of the cast and insists that a panel be remade if a worker forgets to include those details in the cast.[51] If the wall is a witness, is the electricity always buried within it standing for the optical nerves?

Perhaps it is not surprising that once the wall has been conquered, Whiteread changes medium and method. From plaster and concrete to transparent material, from the Brutalist architecture of *House*, to the delicate glasslike architecture of *Monument* (2001), a replica in clear resin of an empty plinth in Trafalgar Square. Set on top of the original granite plinth as its "ghostly mirror image," it reflects the buildings, the people, the traffic, the pigeons, the clouds . . . and changes color with every shift in the light. Fourteen feet in height, weighing eleven and a half tons, *Monument* is the largest piece of resin ever cast. In many ways the piece is a development of her cast resin *Water Tower*, installed in New York in 1998, of which Whiteread said: "All my previous work had a definite solidity to it. I wanted to make a work that had an inherent transparency so that its internal as well as its external structure could be revealed. . . . I tried working in glass at one point but it's not possible on that scale."[52]

With *Monument* Whiteread has achieved a much higher degree of transparency than with *Water Tower*. Like a building of modern architecture, it is a clear frame for the world around it. It seems to represent a fundamental shift in Whiteread's work. The negative cast exposing the secret life of an absent domestic object gives way to a positive cast juxtaposed with the original granite plinth, a piece of city furniture. But the medical body has not been left behind. On May 27, 2001, a journalist from the *Observer* described Whiteread putting the finishing touches on the piece in "surgical gloves wielding a dentist pick in one hand and a syringe in the other, going around the cast picking up blisters on the surface, and injecting more resin to fill the holes."[53] And in a photograph of the almost completed work in the *Independent Magazine*, Whiteread even appears looking down at us from inside the transparent surfaces of *Monument*. She is finally in the wall.[54]

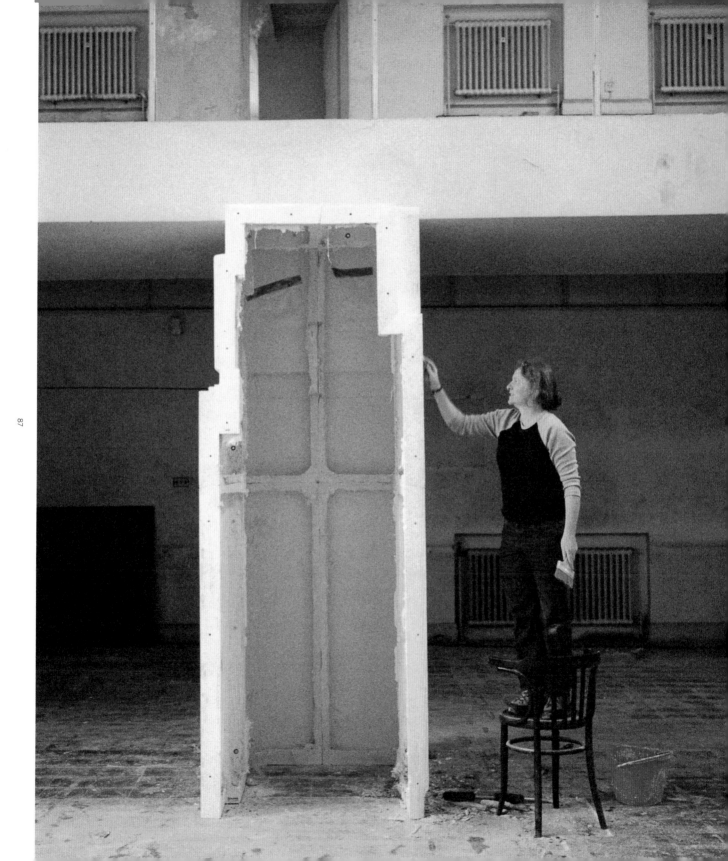

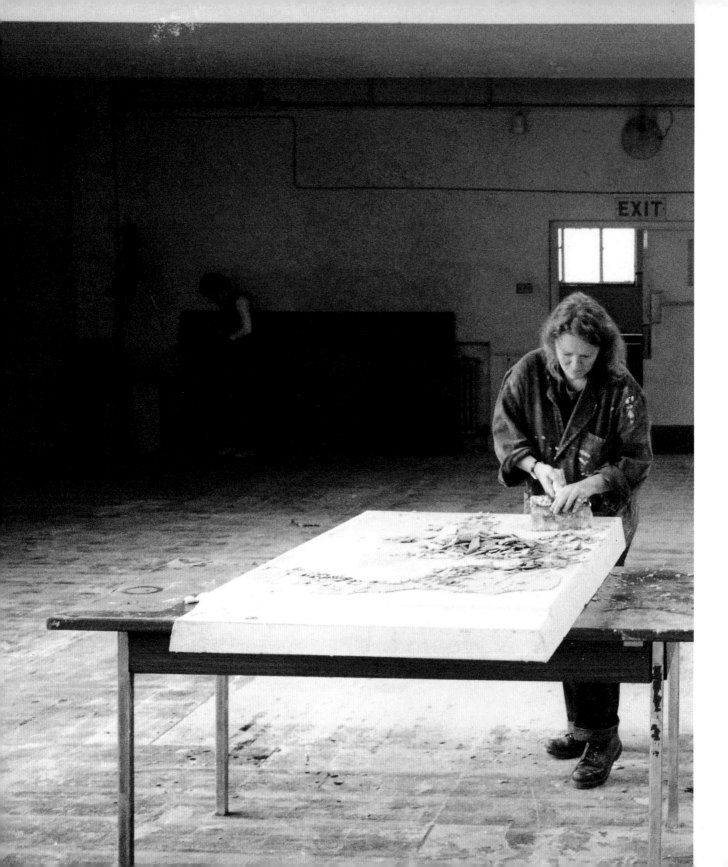

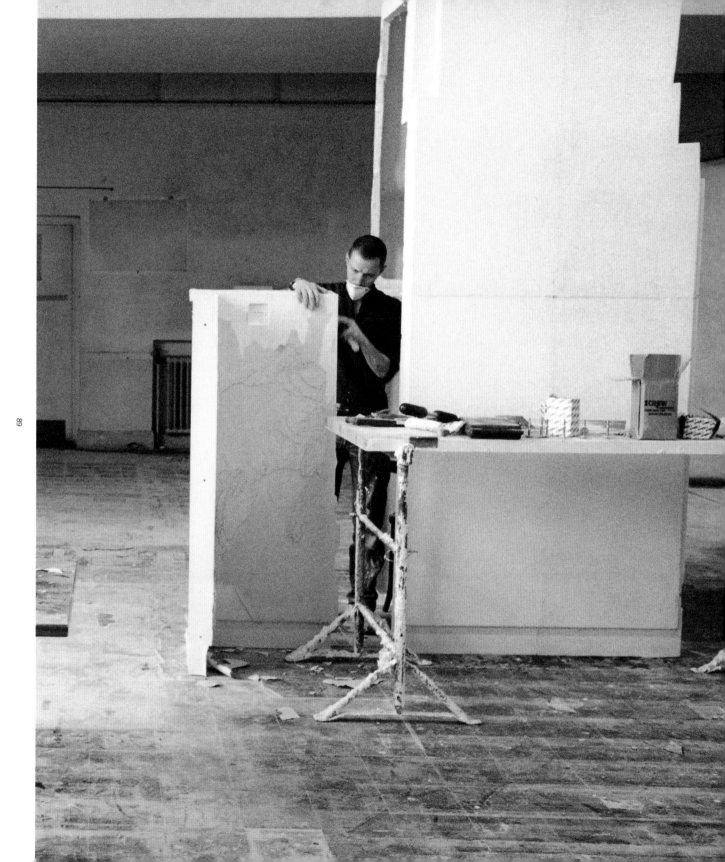

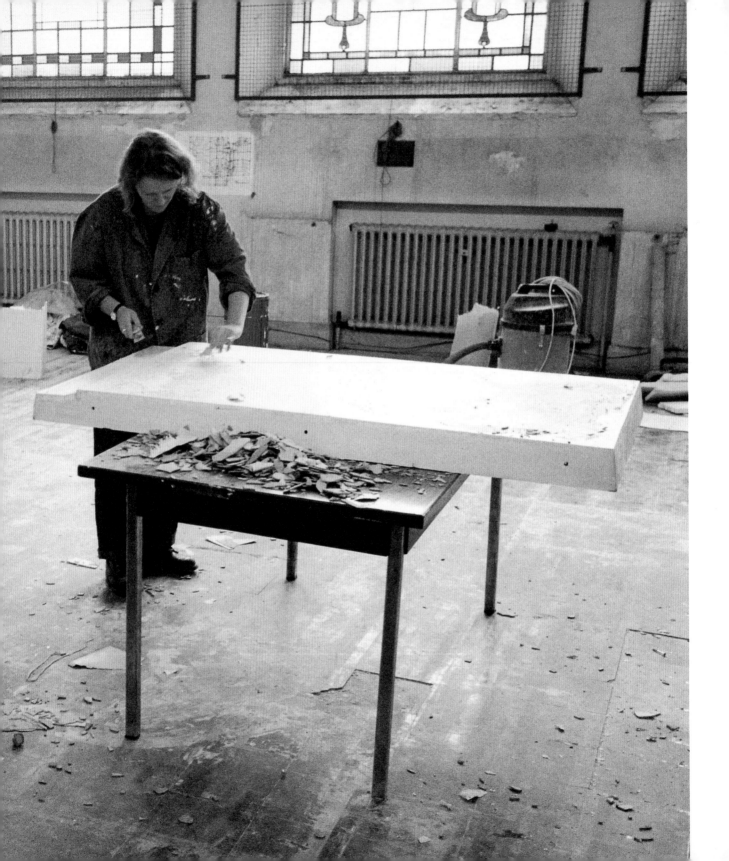

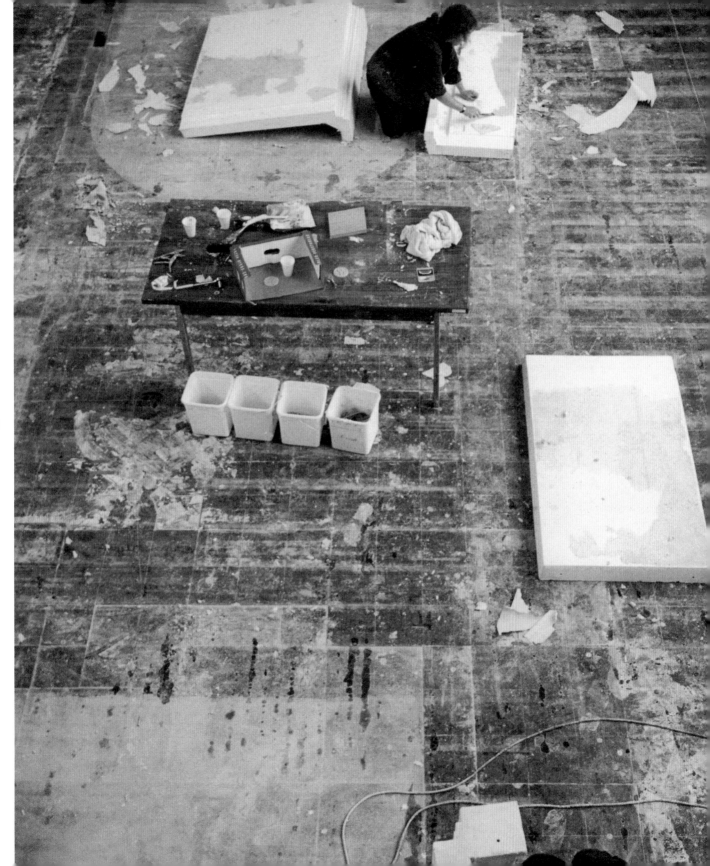

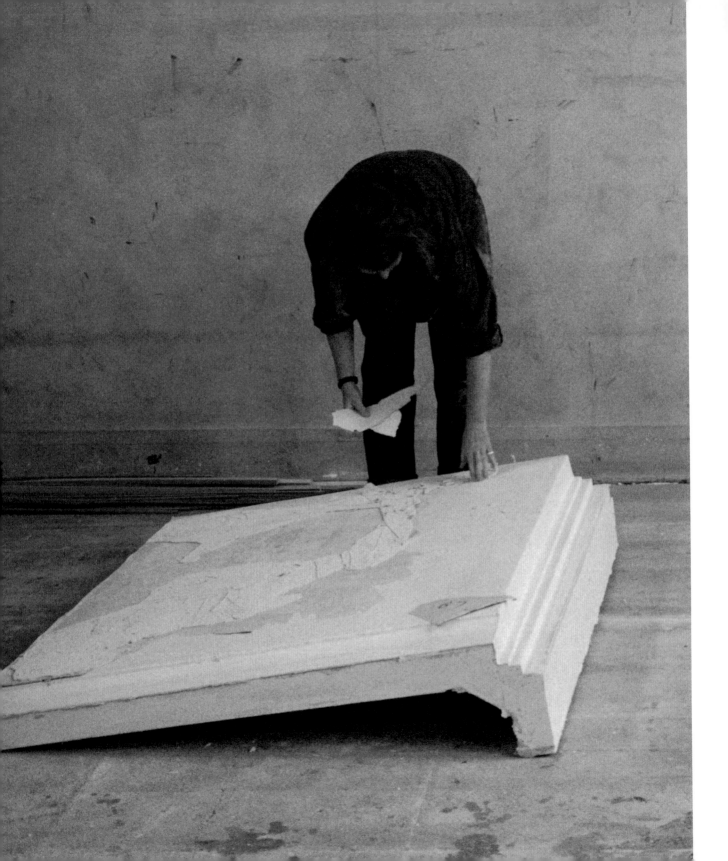

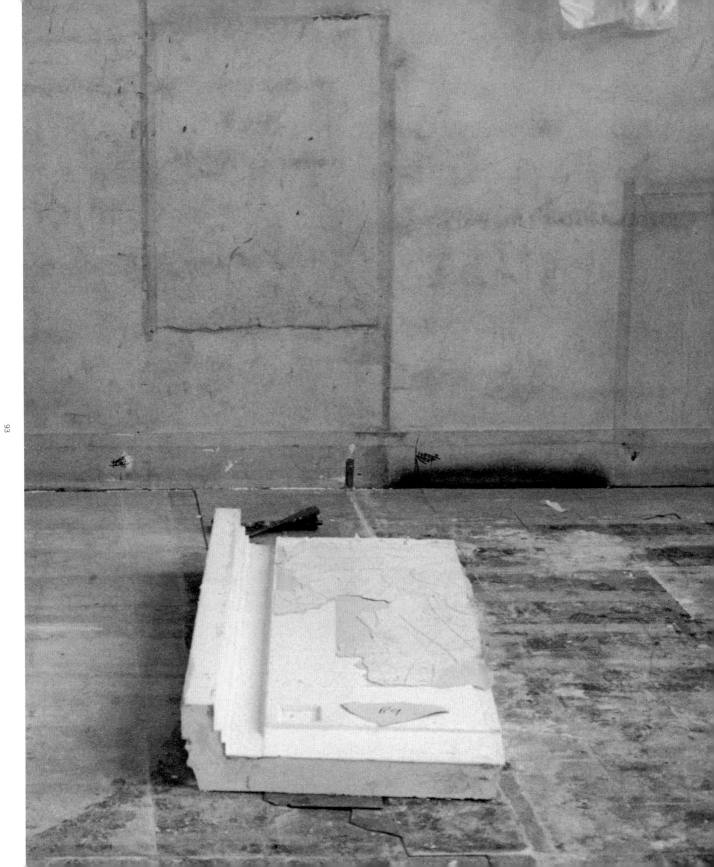

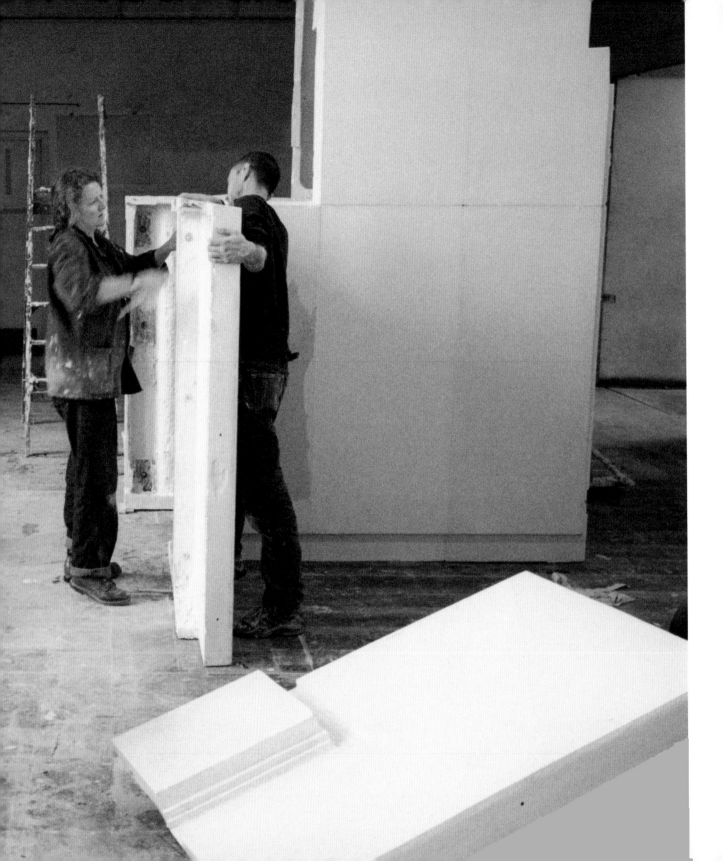

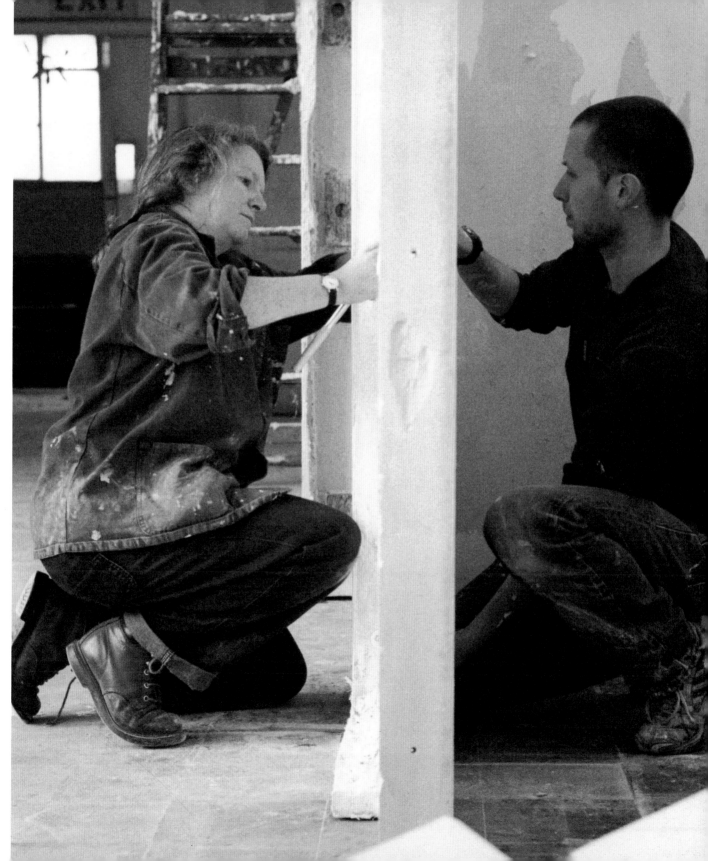

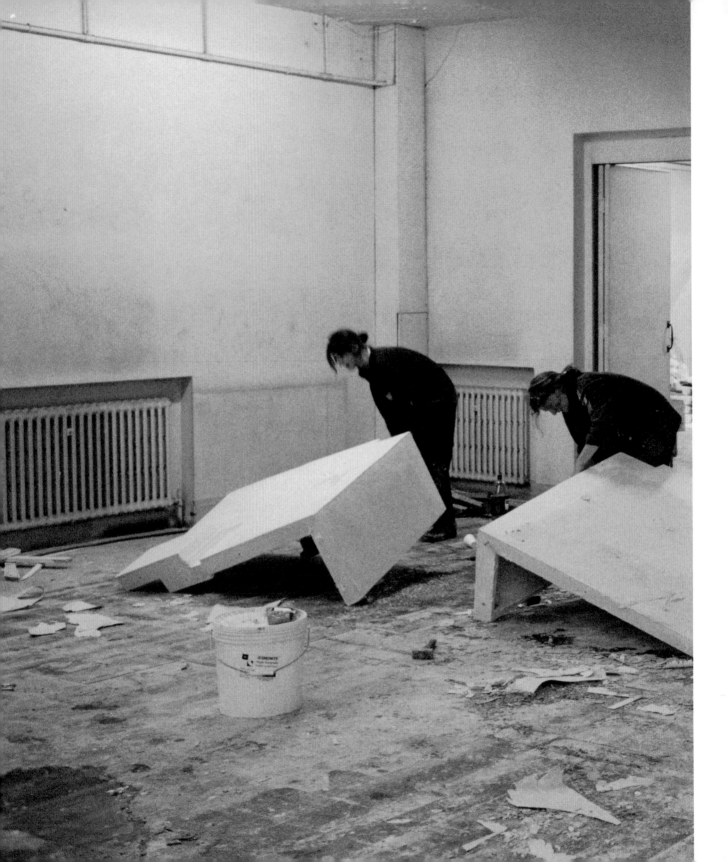

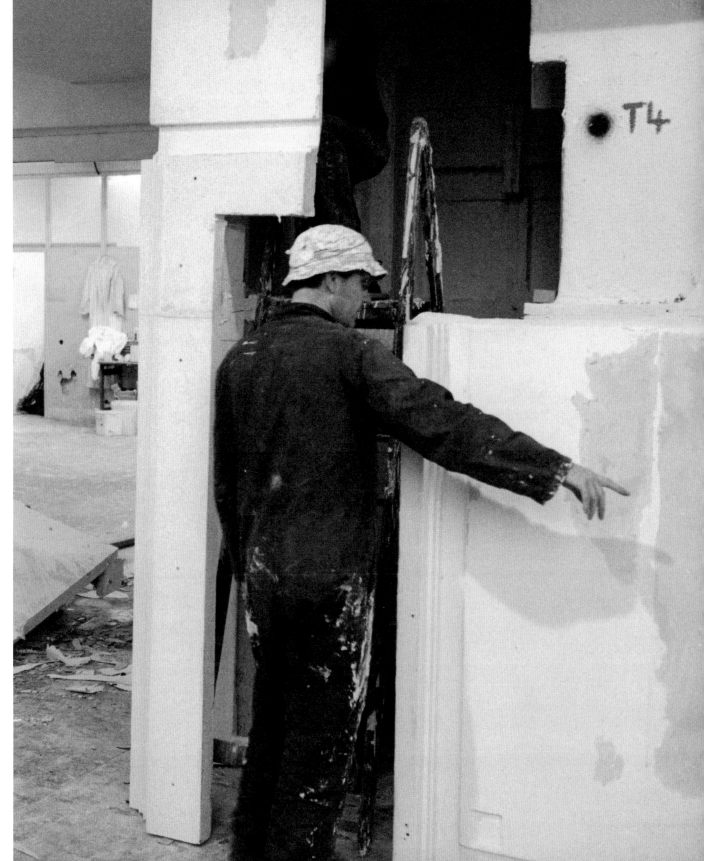

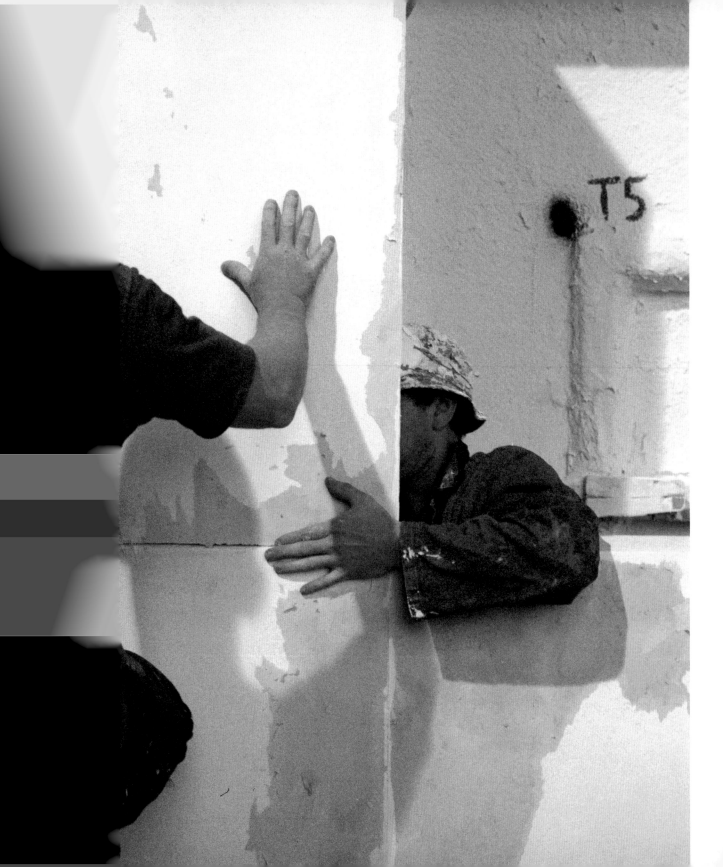

In the morning there are marks, where the pillow touched his face, where his T-shirt wrinkled against his back, the waistband of his underwear, elastic indentations, ghostly traces. He peels off the socks he wore to sleep, the pattern is like a picket fence. With her fingernail she writes on his chest, Milk, Butter, Eggs, Sugar. The invisible ink of her finger rises up like a welt. In the shower it becomes perfectly clear—dermatographism. For the moment he is a walking grocery list—it will fade within the hour.

"I dreamt I was in the eighteenth century having tea in a very elaborate cup." He is a clock maker lost in time, keeping track of the seconds, fascinated by the beats, hours passing, future becoming past. "And you? How did you sleep?"

"I dreamt the building was sealed, there were no doors, no windows, no way in or out, nothing to knock, nothing to ring, nothing to bang against," she says. "The house of glass was suddenly all solid walls."

"You are what you dream," he says.

"It's true." She puts on her shoes, slipping a small piece of lead into both left and right, to keep her mind from wandering, to keep herself steady. "I'm late," she says.

"You have a feather," he reaches out to pluck something sticking out of her skin. She sometimes gets feathers; they erupt as a pimple and then a hard quill-like splinter pokes through the same way a feather pokes through the ticking of a pillow or the seat of a sofa.

"Is that the only one?" she asks.

He looks at her arms and legs and pulls out a couple more. "All plucked and ready to go," he says.

"Thanks," she says. "Don't forget the groceries."

He nods. "Yesterday there was a fox in the woods; for a minute I thought it was you. I went to say hello and it gave me an angry eye—you're not angry with me are you?"

"It wasn't me. I was at the office all day."

On her way out the door she puts a clump of dirt in her mouth, presses a pumpkin seed in and swallows for good luck.

"Drive carefully," he says. He sprinkles fish food into the pond of koi, flips a penny in, and waves good-bye.

Outside the lawns are being watered, the garden men are going around with their Weed Wackers, trimming, pruning. Everything is shape and order. There is the tsk, tsk, tsk, hissing tick as the sprinklers spit water over the grass.

Winding down the hill, the landscape reminds her of Japan, of Scotland, of

Archaeology of Time

A. M. Homes

another country in another time. There are big rocks, boulders, and sand like a desert, dense vegetation clinging to the sides of craggy hills. There are palm trees, and date trees, and orange and lemon groves. Along the side of the road a man is painting a fence. She remembers her mother giving her a paintbrush and a coffee can filled with water and sending her out to paint the fence around their house. She remembers the wood turning dark with water and then light again as it evaporated.

There is fog in the canyons, a hint of blue sky at the top of the hill. The weather changes from block to block—it is impossible to know what kind of day it will be.

She sits at her desk, pouring over drawings, reading between the lines. Her workspace is industrial, minimal: a skylight, an exposed wooden ceiling, furniture from an old factory.

Four pens on her desk, ten paper clips, a plastic spoon. Twenty steps from her desk to the door. She is always counting. There is something reassuring about numbers, she does math in her head, math to keep herself entertained, to keep everything in order.

Magnetized, she attracts things—right now she has a paper clip on the tip of every finger like press-on nails. When she's bored, she decorates herself in loose change, quarters all up and down her arms. Her watch clings to her wrist, cinched with her heartbeat. Her pulse an even sixty beats per minute. When she exercises, she takes the watch off, afraid of breaking time.

"You are a magnetic, highly influential person," a psychic once told her. "People and things are drawn to you."

Making herself a cup of tea, she puts in a pinch of catnip—it makes her pleasant and playful. When she smiles, a thin line of soil at her gum line is easily mistaken for a tobacco stain.

Architectural forensics is her field—why buildings do what they do. Often called upon as an expert witness, she is known as "X-ray specs" for her ability to read the inanimate, to intuit what transformed it, to find the otherwise invisible marks of what happened and why. There is something in her coding that allows her to absorb information and memory—her own and others. She is the one you want to call when there is a problem to solve—cracking, sinking, the seemingly inexplicable.

Her first appointment is a disaster. From the moment she's out of the car, she's uncomfortable. She has flashes of things she doesn't want to know—other people's memories. The owner meets her in the parking lot. "It's a liability question. It's an insurance question. It's a question of who's going to pay," he tells her, as he sweeps

a single long lock of hair across his bald head and sweat pastes it down.

"There's something wrong with your facade," she tells him.

"A partial collapse," the owner says, pointing at the damage.

She circles the building. If the man weren't watching, she would make herself into a squirrel or a bee and get inside it. She would get between the walls, between what was original and what was applied later without thinking. Instead, she simply uses an extension rod and pokes at things.

The owner moves to let her into the building.

"Old keys have more power than new," she says, as the man fumbles.

"Could I have seen it coming? Could I have known? There was no warning."

"Or was there? Just because you don't see it doesn't mean it isn't there—there is something called willful blindness."

"Is that a legal term?" he asks, nervously.

"No," she says getting back into her car.

"Don't you need to get inside?" he asks.

"I've seen enough," she says.

"A woman died," the man confesses.

She already knows.

A click of the shutter. Her day is spent looking, taking notes with her camera, making permanent what she sees in her mind's eye. She is a kind of special anthropologist, studying what we can't touch or see. She drives, moving through air, counting the molecules.

She is thinking of shapes—volumes, groined vaults of Gothic cathedrals, cable roofs, tents. She is thinking of different kinds of ceilings. She is noticing there is a lot of smog, a suffocating layer.

As a child she fell down a well, like something from a nursery rhyme. "That explains it," her teachers used to say, but it didn't. One thing had nothing to do with the next except that she was curious, always curious, but there was much more to it than that.

She walks with a slight limp, an unnecessary reminder. She remembers the well, she remembers thinking that she saw something there—she was eight, almost nine—leaning over, catching a glimpse in the corner of her eye.

She remembers screaming as she fell, the echo of her voice swelling the well. Wedged, her leg oddly bent. She remembers silence.

And she remembers her mother shouting down to her, "Imagine you are a bird, a winged thing and push yourself up. Imagine you are a flower, growing, imagine

you are something that can scale a stony wall. Her mother shouting: many, many hours of firemen and ropes. She remembers thinking she would fall to the center of the earth, she remembers the blackness. And her picture in all the papers.

After that, while she was in bed healing her broken leg, her mother would hold her hand and stroke it, "What does it feel like to be a kitten? What does a little kitten hear or see?" And slowly her features would change and she would be a little kitten-headed girl. "And what does a kitten do with her paws?" her mother would ask, stroking her hand and little furry mitts would appear. "You're very special," her mother would say, "When you fell down the well, you didn't know that."

She nods, still not sure what her mother is getting at—aren't all little girls special?

"Some children are born with a fine coating of hair but when you were born you had feathers—that's how I knew. When you were living inside me you were a duck, splashing. You know what a good swimmer you are—you had a lot of practice."

Looking out over the city, she receives a thousand messages at once, a life of information.

The next stop is more promising. A developer wants her opinion about where to build his building.

"You come highly recommended," the man says, unrolling his plans across the hood of her car.

She reads them. Her eyes are like sea water, Mediterranean blue. When you look at her you have the distinct sense that she's right.

"If I were you," she says, "I'd build in reverse, I'd build the building into the hill, and then on that hill install a big mirror. Situate the mirror so that it gives you a view on both sides, put the parking lot above rather than below. You'll get a double view, an interesting courtyard effect and more protection from the wind.

"The wind?"

She opens her trunk, takes out a white flag and holds it up. The flag is instantly billowing. "It's windier than you think and when you build a new building that will change even more. You could end up creating a wind tunnel: the Venturi Effect—increased wind speed when configuring air flow."

"I never heard of that."

She puts the flag back in her trunk.

"What else you got in there?" he says peering in.

Shovel, gallon of water, long green garden hose, ladder, rope, rubber gloves, Zip Lock bags, small containers, knee pads. She is always climbing, swinging, getting on top, going under.

She bends to sift through the soil. "This looks sandy. Sandy soil has a liquefaction factor," she says. "In an earthquake it's not the 'this' that gets you," she says moving her arm from side to side. "It's the 'this.'" She pumps her hand up and down. "A lot of it has to do with what kind of soil is down below."

The man scoops up some dirt. "Is that a good thing?"

"It's a good thing you know about it and can plan accordingly. It's all about what rock you're on."

"I appreciate your insight." He shakes her hand. His handshake is firm. "Thank you."

All day the building collapse haunts her, she keeps seeing the sticky guy sweeping sweaty strands of hair across his scalp, pasting them down. He is slimy, slithering, slipping in and out of lies. She has the sensation of great weight, of something falling on her, crushing. She feels out of breath. She keeps in motion to keep herself from feeling trapped.

She stops for lunch at the health food store. The boy behind the counter sings her a song he's just written. "I'm here now," he says. "But it's temporary." Everyone is something else, everyone wants something more. Elusive, ethereal— it's always something.

She is back at the office. People bring her samples of materials, combinations of things. They want to know what goes with what. What brings success, power. What juxtapositions spell trouble? What do you think of titanium? Curved surfaces? How much does a building really need to breathe? They want to know how she knows what she knows. "Did you study Feng Shui?"

The temperature creeps up—the air is still, like the steady baking heat of an oven, unrelenting, broken only by the shadow of a cloud passing over.

In the afternoon, she visits her mother. The doors of the nursing home open automatically; a cool disinfectant smell pours out. Vacuum sealed, frozen in time. There is an easel by the main desk: Good Afternoon. The year is 2001. Today is Wednesday, May 16th. The weather outside is Sunny and Warm. Her mother's unit is behind a locked door. There is a sign on the wall: "Look as you are leaving, make sure no one follows you."

Her mother doesn't know her anymore. It happened over the course of a year. The first time she pretended it was a mistake—of course you know me, she said. And her mother seemed to catch herself, but then it happened again, it happened

more, and then sometimes she knew her, sometimes she didn't—and then she didn't.

Every day, she visits. She brings her camera, she takes a picture. It is her way of dealing with the devastation, the rug pulled out from under.

"Hello," she says, walking into the room.

"Hello," her mother repeats, echoing her like a parrot.

"How are you today?"

"How are you today?"

"I'm good," she sits at the edge of her mother's bed, unfastening her mother's long braids, brushing her hair.

"Remind me," her mother says. "Who are you?"

"I'm Suzanne—your daughter."

"What makes you so sure?"

"Because I remember you," she says.

"From before?" her mother asks.

She nods.

"My sock is itching," her mother says, rubbing the tag around her ankle. All the residents are tagged—an alarm goes off if they wander out—the tag leg is alternated, but it remains an irritant.

"What can we do?" the nurse says. "We don't want to lose anyone, do we?"

She rubs lotion on her mother's leg. She puts a chestnut in her mother's pocket just as she once saw her mother do to her grandmother—to ward off backaches. She puts an orange she picked this morning on the nightstand, resting on a bed of clover. Protection, luck, vision.

She takes her mother for a walk in the wandering garden, an inconspicuous circle, you always end where you begin—it guarantees no one gets lost.

"Let me take your picture," she says, posing her mother by some flowering vines. "You look very pretty."

"You look very pretty," her mother says.

Holding her mother's hand, they walk around and around.

"I hope you remember the way home," her mother says.

"Remember when I fell in the well. Remember when you told me how strong I was and that I had to put my mind to it."

Her mother nods. "I used to know something," her mother says. "Have you always had a limp?"

She visits her mother and then visits the other women up and down the hall. "Imagine us," they say, "sitting here, like lame ducks. We see it all. There but

for the grace, go I."

When her mother is gone, she will continue to visit, to visit the unvisited. Every day she touches them; they are wrinkly, covered in barnacles and scars, filled with secret histories, things no one will know. She touches them and their stories unwind.

"You look familiar," one of them says. "I know you from somewhere."

"You know me from here," she says.

"Where was I before this?" the woman asks. "Does anyone know where I am? I'm missing," she says.

Another woman runs through the rooms, opening all the dresser drawers, searching.

"What are you looking for?" the nurse asks.

"I am looking for something," she says in tears. "That's what I'm looking for."

"Describe it to me," she says, laying her hand on the woman's arm.

"I don't know exactly what it is. I'm looking for something that I recognize. I think maybe I'm in the wrong place. If I could find something familiar I would know where I belong."

She brings them pictures of themselves.

"Is this who I am?" they say.

She nods.

"Sexy aren't I?"

The sea. She drives to the ocean and parks. She takes a picture. She finds the fact that she is not the only one moving calming.

She is a navigator, a mover, a shifter. She has flown as a gull over the ocean, she has dived deep as a whale, she spent an afternoon as a jellyfish floating, as an evergreen with the breeze tickling her skin, she spent two days as water and found it difficult to recover. A seer, she is in constant motion, trying to figure out what comes next.

It is early evening. The sky is charcoal, a powdery black. Everything is a little fuzzy around the edges and then sharp and clear in the center. She is a coyote at the edge of the grass: her shoulders like hips, her spine elongated, her nose pushing forward and her skull rolling back. There is something slippery about the coyote—a million years of motion, of shifting to accommodate, keeping a fluid boundary—she is coated in a viscous watery solution.

She digs through the bushes. There is a girl in the backyard, floating alone on a

raft in the water. She walks to the pool, dips her tongue into the water and sips.

She hears the girl's mother and father in the house. Shouting.

"What am I to you?" her mother says.

"It's the same thing, always the same thing, blah, blah, blah," her father says.

"Your life is like a movie," the coyote tells the girl. "It's not entirely real."

"Tell me about it," the girl says.

The coyote starts to change again, to shift. Her skin goes dark, it goes tan, deep like honey and then crisper brown like it is burning, and then darker still towards black. Downy feathers begin to appear, and then longer feathers, like quills. Her feet turn orange, fold in and web. A duck, a big black duck, like a crow, like a Labrador, but a duck. The duck jumps into the pool and paddles towards the girl.

They float in silence.

Suddenly, the duck lifts her head as if alerted. She pumps her wings and rises from the water. She is heavy, too heavy to be a duck, her body is changing again, she is trading her feathers for fur, a black mask appears around her eyes, her bill becomes a snout. She is standing on the flagstone by the pool, a raccoon, with orange webbed feet. She waddles off into the night.

There is a tremor. The lights in the house flicker, the alarm goes off. In the pool the water shifts, a small tidal wave sweeps from one end to the other, splashing up onto the concrete.

She hurries back to the car, shifting back into herself. She rushes towards home. The tremor is on the radio news. "A little rock and roll action this afternoon for you folks out there," the disc jockey says. "The highways are stop and go while crews are checking for damage." She takes surface roads, afraid of the freeways, the overpasses, the spaghetti after a quake.

She pulls into the driveway, the house is still standing, nothing seems terribly wrong.

Every day she carries a raw egg in her pocket, to collect the negative flow of energy—it acts like a sponge, absorbing it, pulling it away from her. At the end of the day she smashes it back to earth, the front yard is littered with white egg shells.

Her key doesn't work, the small rumble must have caused a shifting of the tumblers, a loosening of the lock, it goes in, but won't turn. She is knocking, she is ringing the bell, going back to the car and tooting the horn.

"I dreamt I couldn't get in," she says, when Ben opens the door.

"The lock is broken," he says, turning the knob. "Your hair is wet."

"I stopped for a swim."

"And I think you lost your shoes," he points down to her bare feet. They are

almost back to normal, the middle three toes for the moment remain webbed and orange, but they're on their way. "I rushed back. Are you all right?" she asks him.

"Fine. Everything is fine. The front window has a crack," he says.

"Stress fracture," she says. "Did they call?"

He nods. "About fifteen minutes ago, I reported vibration and minor damage."

In their backyard there is a global positioning monument, a long probe sunk deep into the earth. Every thirty seconds one of five satellites registers the position of the monument, measuring the motion in scientific centimeters. There are hundreds of them, up and down the state. She and Ben get a five hundred dollar tax credit for "the friendly use of land." And every time there's an event, the phone rings. "Just checking in."

When she stands near the monument, when she focuses on it, she can feel the satellite connecting, a gentle pull for a fraction of a second, a tugging at the marrow.

"There are footprints," Ben says, pointing out the press of a paw on the loamy ground behind the house. "I'm thinking dog or deer."

"Mountain lion," she says, bending to sniff the print, pressing her hand into the dirt over it.

Ben takes a dry towel and rubs her hair, at the roots her hair is fluorescent orange, the rest is brunette. The color changes according to her mood, or more accurately her emotional temperature. The only way she can disguise her feelings or not look like a clown is to dye her long locks. "Are you especially frightened?"

"The tremor threw me," she says. "Do I need a dye job?"

He nods. "You're bright orange."

She is saving the strands, weaving a carpet of hair for the floor in the bedroom, cleaning her brush, her comb, spinning it like a Technicolor carpet.

"Did you go out today?" She noticed that all the grocery bags on the counter are from IDot.com, the on-line food store—type in your list and your groceries are at the door within an hour.

"The pollen was high," he says. "The air was bad. I stayed inside, working. I made you a wonderful puzzle."

Ben is perfecting a kind of time-sensitive material, a puzzle that shifts so that the image changes as you are piecing it together. Every day he downloads photographs and turns them into something new. This time it's a picture of the sky at twilight, a single cloud. As they put the pieces together the blue deepens, it becomes an image of the night sky and as more of the pieces fit, a small plane flying across the sky moves silently from piece to piece.

In every room there is a clock. Ben likes listening to the ticktock, tripping of the hands as he moves from room to room, as sound shifts, time bends.

He runs her a warm bath and sits by the edge while she soaks—ever since the fall in the well, she can't bear to be in water alone.

"Benjamin, are you still thinking you can stop time?" she asks as he washes her back.

"I'm working on it," he says.

"How well do you know me?"

"Very well," he says, kissing her. Her skin is the skin of youth, of constant rejuvenation, delicate, opalescent, like mother of pearl.

"Is there a beginning or an end?"

"No beginning or end in sight—infinity."

Out of the bath, he wraps a towel around her.

He presses his mouth to her skin, telling her stories.

Her heart races, the watch on her arm ticks faster, she begins to shift, to change, first she is the coyote, then a zebra, a mare, and a man. Her bones are liquid, pouring. She is laughing, crying in ten different languages, barking and baying. His hands slide over her skin, her coat, her fur, her scales, her flippers and fins. He is sucking the toes of a gorilla, kissing the ear of a seal. She is thick and thin, liquid and solid.

They are moving through time: lying on pelts in a cave, in a hand-carved bed in a palace, nomads crossing the desert, calico pioneers in a log cabin, they are on a ship, in a high rise, on the ice in an igloo. Their cells are assembling and disassembling. They are flying through history. She is a cloud, vapor and texture. She is rain and sky and she is always and inescapably herself.

"Is that still you?" he asks. "I never know if you're really in there."

"It's me," she says, sliding back into herself. "In the end, it is always me."

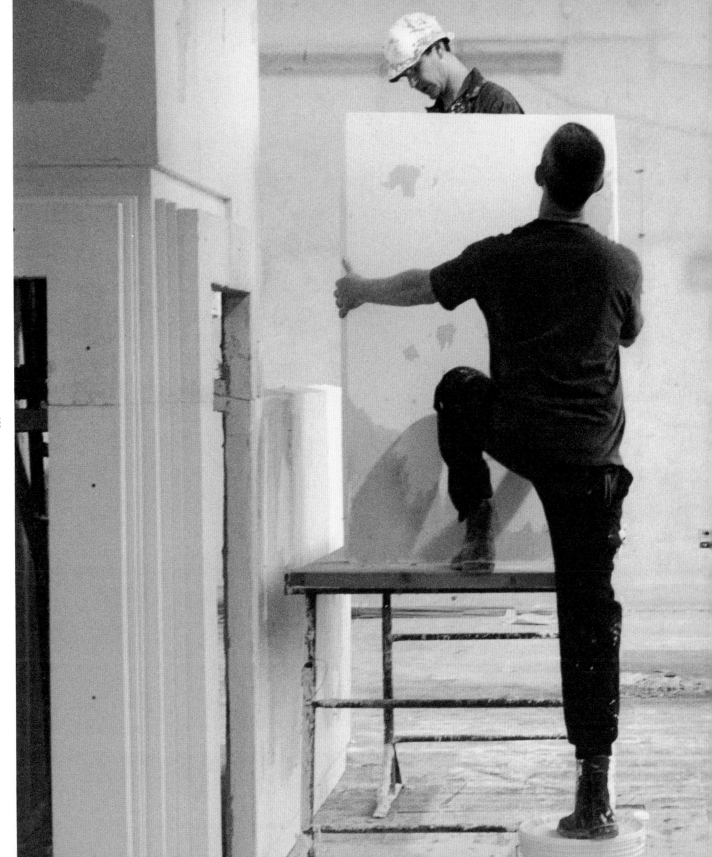

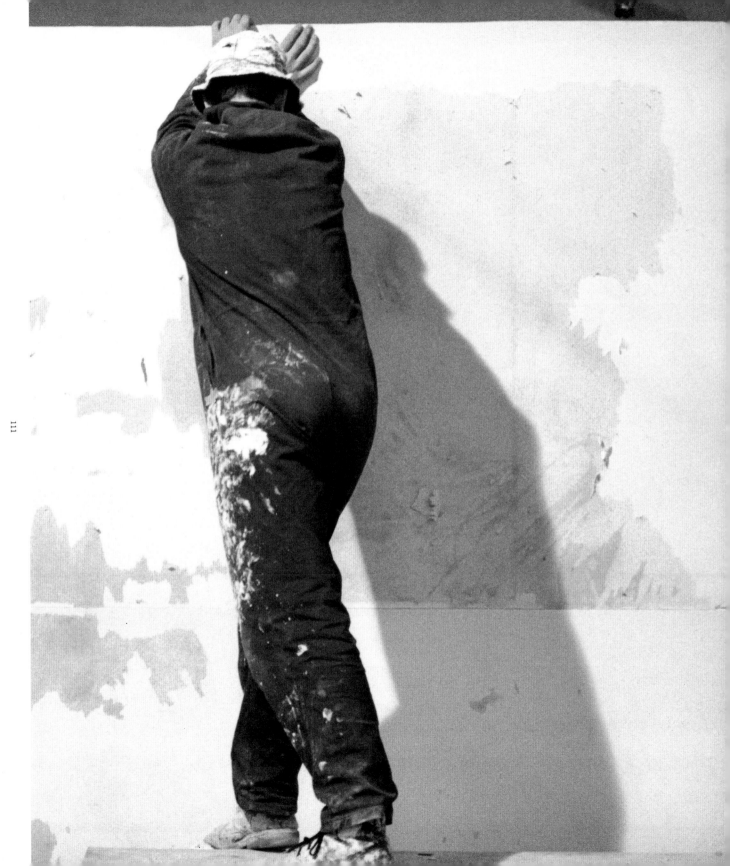

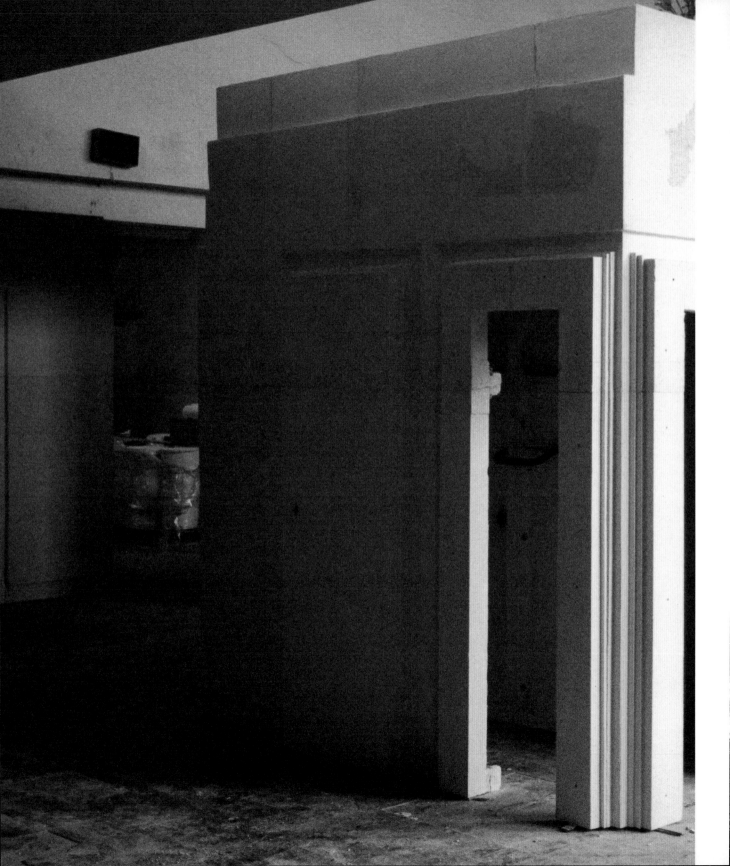

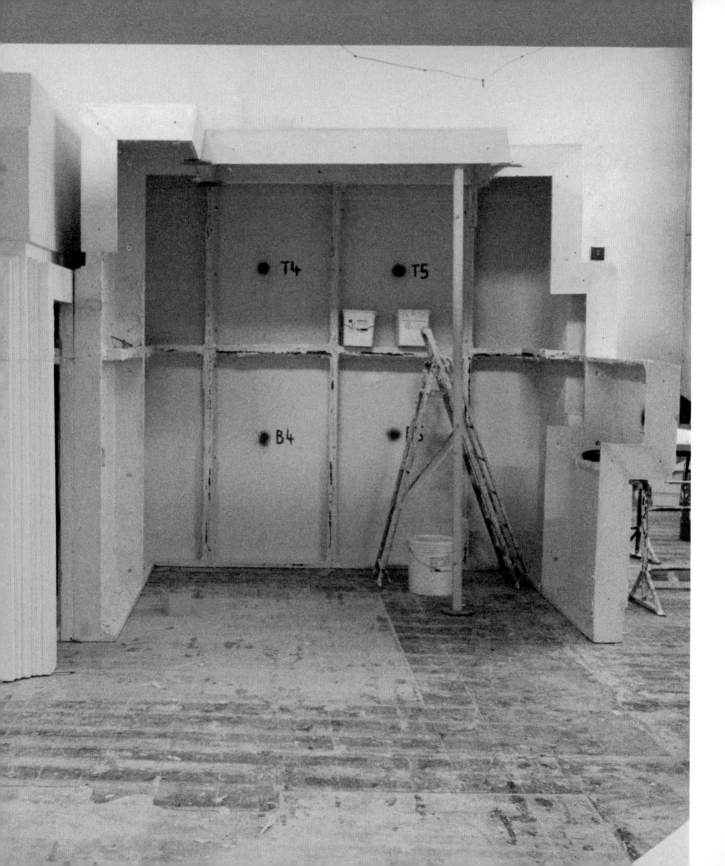

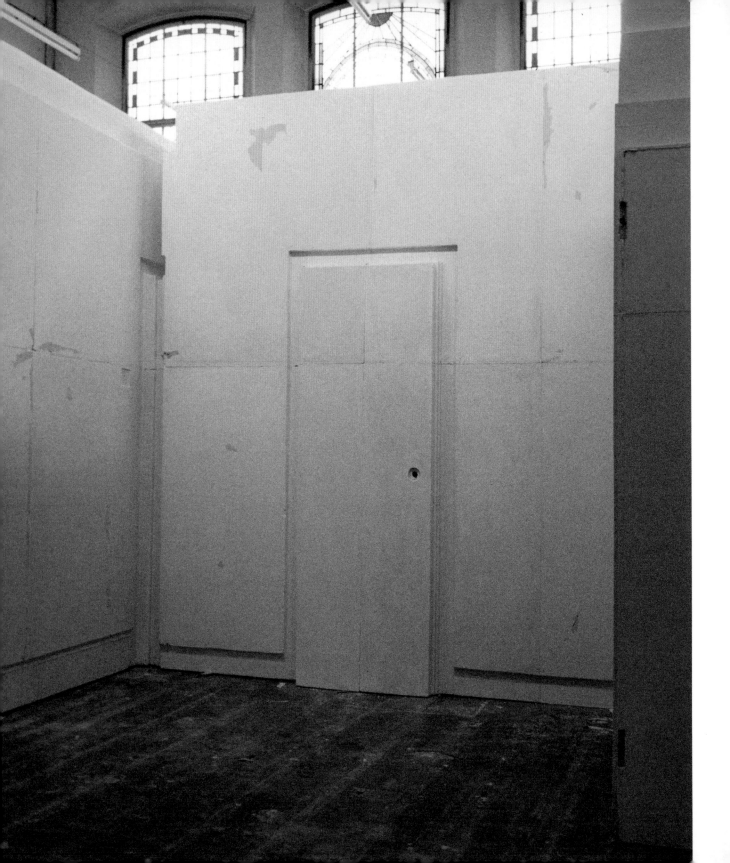

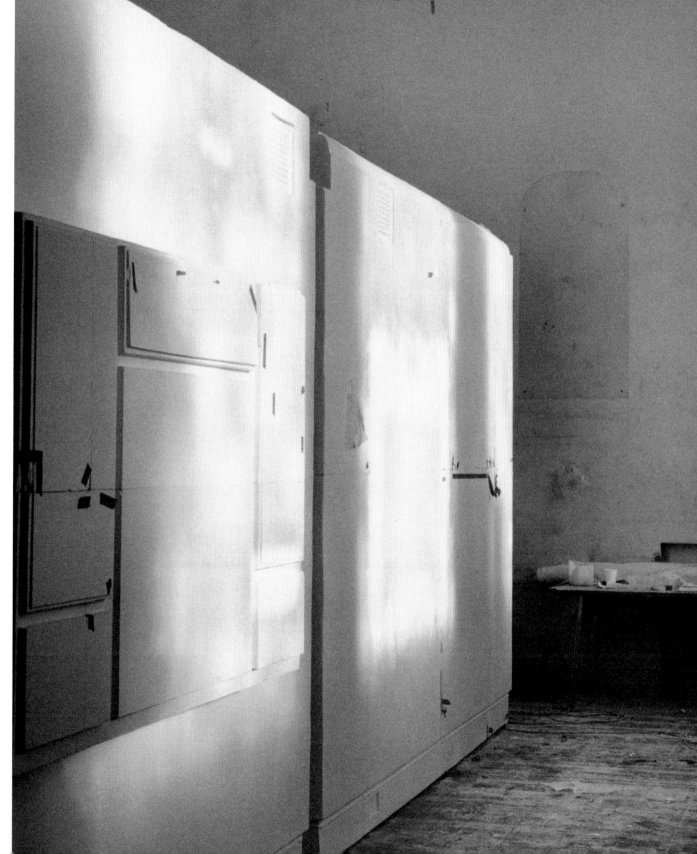

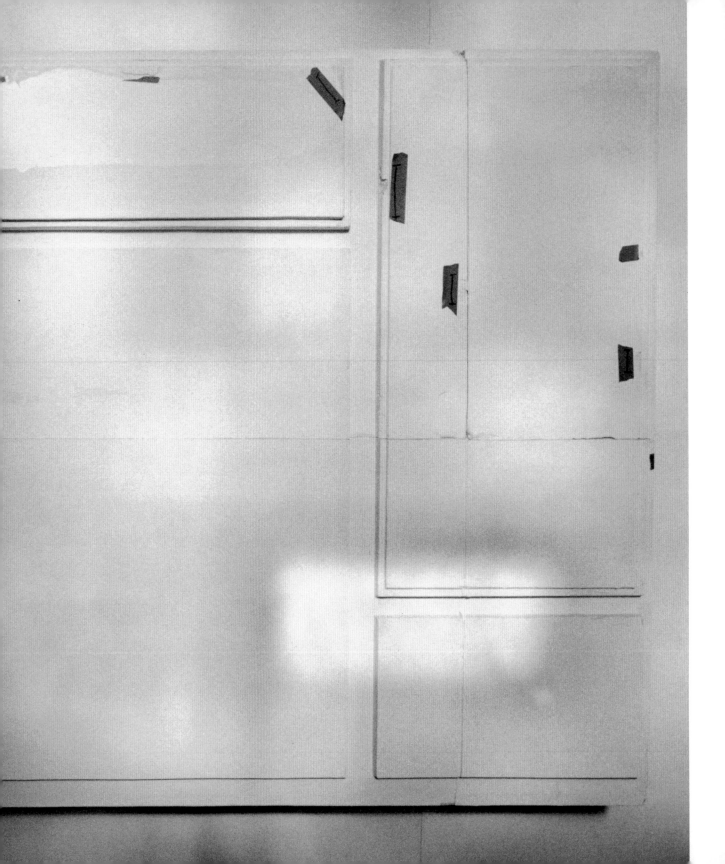

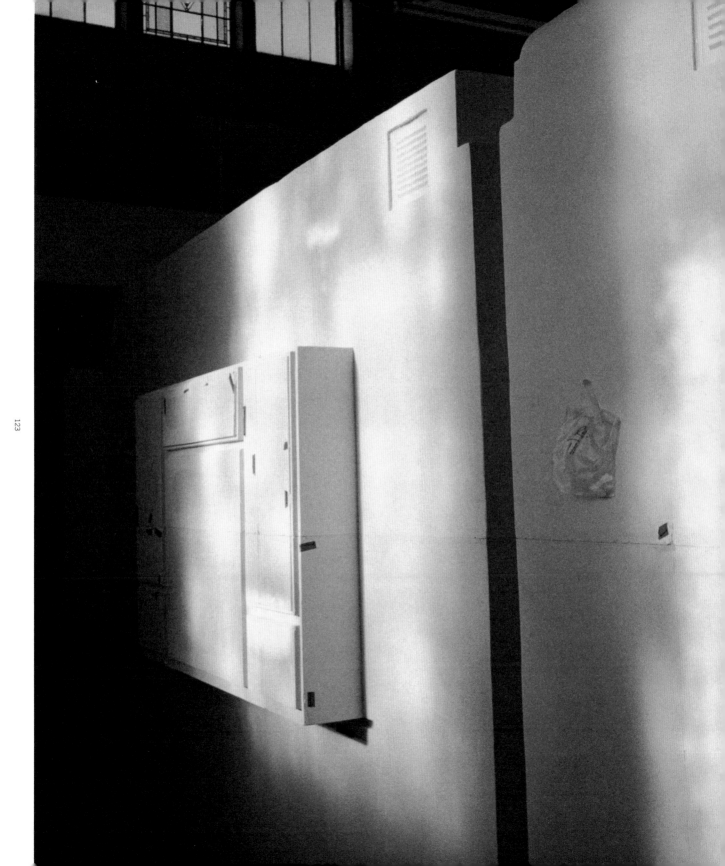

Untitled (Basement)

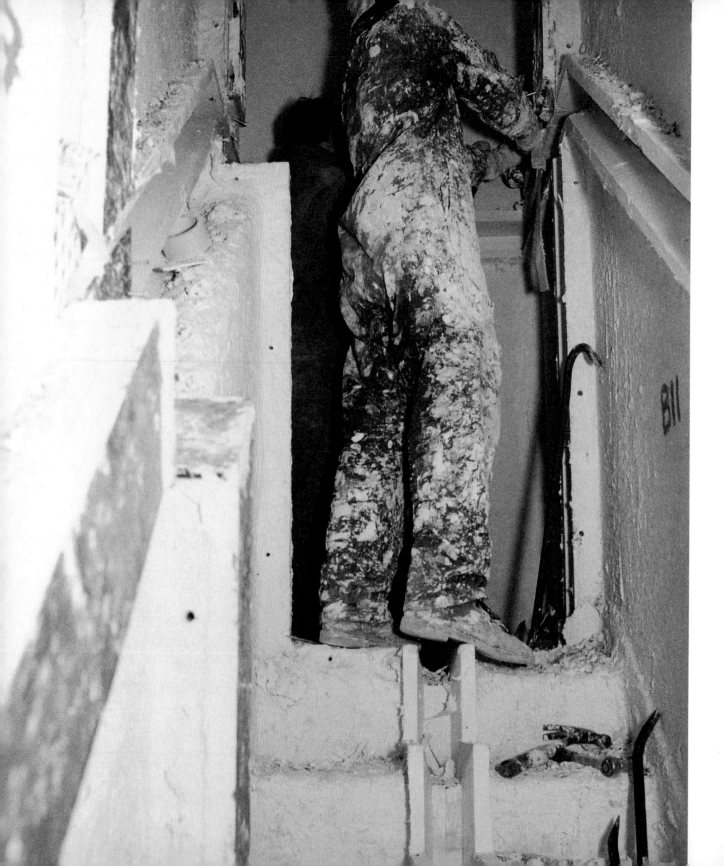

Casting is a process. It takes steps. A surface is encompassed, flooded, or smeared with a material that hardens over and against it. Eventually, the material can be pulled away. A mimetic transfer has been left on the material. It has acquired an imprint, a negative, of the surface. At this point another set of steps can ensue, since the negative itself can be cast in turn, becoming then a mold for pouring a new object. If cast again, the surface returns, positively mimetic. Here, we say, pointing a finger high, is the true copy. But is this copy the caster's one true end? Casting being a process with steps, it can become a flight of steps, or it can stop on one and stay.

Rachel Whiteread typically stops her work midflight, on a step. The process of casting is ancient, progressive, traditional, but Whiteread's sense of casting allows her some range within the rule. She does not, like Rodin, model a statue in plaster, make a mold of it, and cast a bronze positive from that, arriving more classically at a *Thinker* or *Gates of Hell*. She usually casts from found objects or found spaces and stops after making the mold. Her cast stays content with the negative, the first step, the inversion, the conundrum. This can bring different confusions to bear, as with her interiors of rubber hot-water bottles, solids she decided to name *Torsos* (1988–96), adding that they looked like headless, limbless babies, pinched and poked in the casting, rather like pillows.[1] Sometimes a cast becomes a mold from which she makes another cast to achieve, for example, a completely hard air mattress. All of her steps seem to carry the best and worst associations. *Ghost* (1990), her first cast room, she explained, "was like a 'plaster cast' covering the room in plaster, inch by inch, building it up and securing it with scrim, a tactile process. It was like covering a broken limb."[2]

Over the years her materials have shifted. There have been plaster, rubber, concrete, pink and yellow dental plaster, resins whose colors derive from their catalysts, felt, iron, aluminum, and patinated bronze, but her choice of casting as the process through which to get a form to come, life-size, has not. Almost always Whiteread casts from used objects or surfaces. She wants her material to bear the shadow of the object, the residue of anonymous use, although she can always control the amount and look of the residue by manipulating the process.[3] For the casts commissioned by the Deutsche Guggenheim Berlin of synagogue apartments and staircases, a blank release agent let the surfaces there go very white. We look upon all of this from the outside.

Casting Out
Molly Nesbit

Stare.
Landing.

It is possible to be satisfied with the negative, satiated by a negative, flooded mentally in one's own turn, perceptually thrust into the zone called surprise.[4] The surprise has

already invaded the process of casting, since the hard negative can only be seen for the first time when the cast is pulled away. Before revelation, obscurity; before the seal is broken, the grim backside of the cast: large screws, wooden stays, a project broken down into panels, rough fiberglass reinforcements giving the impression of thatch. Only when the cast, rough nest, is pulled away does the right side show, an eggshell, newborn, fine. It holds the vision of something that does not exist visually. It can capture air's blanketing touch. But forget the implications that reside in this language of flights and shells and air; birds will not come now to sing. Close and far, this casting uses its steps to take distance from nature. We have been stepped to the other side of life.

Is it death?

Whiteread used to tell odd, ghoulish stories when interviewers came to ask about her work. She told of hours spent in the Egyptian collections of the British Museum, of an odd job cleaning up in Highgate Cemetery. She might go on to tell of a TV documentary showing how the metal coffins at Christchurch Spitalfields had puddled up.[5] She talked of mummifying the air in *Ghost* and the concrete Victorian *House* (1993).[6] Her mother, the artist Pat Whiteread, called *House* "an Assyrian tomb, a monument, with an extraordinary quality of stillness." She said it reminded her of the war, "after the bombing, when the sites of the houses revealed traces of the lives of human beings."[7] And the mattresses?

"Old mattresses, bed bases, etc.," Rachel Whiteread volunteered in 1997, "are very much a part of London's detritus and you see them abandoned everywhere on the streets. I remember seeing a television documentary about a particularly run-down housing estate in Hackney, East London. As the documentary progressed you became increasingly aware of the degradation and poverty in which these people lived. An old blind man living on the estate reported a terrible stench coming from the adjoining flat. Eventually the council intervened and found a man who had died in his bed. He had lain there for two weeks and had sort of melted into his mattress. The corpse was removed and the council cleared his furniture onto the street with the intention of taking it to the rubbish tip. No one came to pick it up. There was this dreadful image of young children playing on the mattress that the old man had died on. I must have seen that film over six years ago but the images have stayed with me. . . . There are all sorts of stories related to the pieces I make. When you use secondhand furniture it is inevitable that the history of objects becomes a part of the work."[8] Stories like these hovered around her work even before it was cast. Stories lay on the

side of the road in the city. Without really knowing them, Whiteread was picking them up. She spoke of taking these things home to cast as one of her ways of drawing. She was consciously using London as a sketchbook.[9]

Can the cast be a story?
Can a story be cast?

Later, all this changed. After spending a year and a half in Berlin and seeing what it meant to use Berlin as her sketchbook, she refrained from bringing stories so directly into play when she discussed her current work. The German side of World War II had cast a long shadow over that city. Now she grew formal when questioned. She asked:

"Have you ever read *The Periodic Table*?"

This question of hers opened a book. Why this book? Why now? For *The Periodic Table* was written in 1975 by Primo Levi. It took Levi's life story, beginning with his Jewish ancestors, scions of Piedmont, and told it as a function of materials, specifically, the elements: the inert (noble) gases (his example was argon), hydrogen, zinc, iron, potassium, nickel, lead, mercury, phosphorous, gold, the list goes on. Was he some kind of caster too? Levi had begun as an aspiring chemist. The elements came to figure into his education, his experiments, his work, his life. His understanding of the Fascist rhetoric of racial purity was filtered through his newfound concepts of chemical impurity; he became the defender of impurity: "I am the impurity that makes the zinc react," he wrote, "I am the grain of salt or mustard."[10]

A grain among the elements, Levi did not sculpt. He became the interrogator of nature herself, Mother-Matter, he called her then, the creator of his enigmas, a sphinx. If he first thought of the elements as allegorical figures for himself and the rest of humanity, his understanding of their place and shape soon changed. His life set him on a path where he allowed matter many figures and forms; his route was punctuated by the confrontation with specific, basic, extremely inflexible elements, defined by properties more than purities. Matter came literally. Levi himself was physically overtaken by the Fascist definition of purity and deported to Auschwitz. There his training as a chemist gained him some small consideration, but his life was saved only by a capricious scarlet fever that kept him behind, left to die, while the Nazis marched the rest of the camp away, hoping to keep the final solution from being overtaken by the Allied advance. Most of his friends from the camp perished in that march. Levi was saved by the Russian liberation. That story however is not

Opposite: Rachel Whiteread, *Untitled (Torso)*, **1992. Plaster, 8.9 x 27 x 15.9 cm. Edition of 12**

1. "Rachel Whiteread in Conversation with Iwona Blazwick," *Rachel Whiteread*, exh. cat. (Eindhoven: Stedelijk Van Abbemuseum, 1993), p. 8.
2. Ibid., p. 14. Also see Whiteread's description of casting in an interview with Hélène Gille, *Un Siècle de sculpture anglaise* (Paris: Galerie Nationale du Jeu de Paume, 1996), pp. 384–85.
3. "I always use secondhand materials, as I want to emboss the residue of use on the surface of the pieces," she explained to Beryl Wright in a March 1993 interview in Berlin. Reprinted in *Options 46: Rachel Whiteread*, exh. brochure (Chicago: Museum of Contemporary Art, 1993), n.p.
4. The most complete discussion of the issues raised by casting, by Georges Didi-Huberman, can be found in Didi-Huberman, ed., *L'Empreinte*, exh. cat. (Paris: Centre Pompidou, 1997). It should be added here that in recent years the imprinting associated with casting has been discussed as a kind of linguistic sign known as the index, which was first isolated as such by Charles Peirce in an October 12, 1904 letter to Lady Welby. In Peirce, *Charles S. Peirce: Selected Writings*, ed. Philip P. Wiener (New York: Dover, 1966), p. 391. Peirce constantly elaborated his sign system and, therefore, the index. See, for example, "Lowell Lecture IX, 1866," in Peirce, *Writings of Charles S. Peirce*, vol. 1, Max Fisch, ed. (Bloomington: Indiana University Press, 1982), pp. 471–88, and "A Survey of Pragmaticism," in Peirce, *Collected Papers of Charles Sanders Peirce*, vol. 5, ed. Charles Hartshorne and Paul Weiss (Cambridge, Mass.: Harvard University Press, 1934), pp. 317–45. The more recent discussion on the topic was initiated by Rosalind Krauss in "Notes on the Index," reprinted in Krauss, *The Originality of the Avant-Garde and Other Modernist Myths* (Cambridge, Mass.: MIT Press, 1985), pp. 196–219. I have not used the term here, since once identified it now tends to stop discussion, as if a con-

narrated in *The Periodic Table*. Levi had already told it too well in the very first book he wrote.

Levi wrote that book, *Survival in Auschwitz*, immediately upon returning home to Turin in 1946. It too was a life story but abbreviated. It recounted, as faithfully as possible, the experience of a life after it had been cast into the camps.[11] Levi began writing a testimony, writing as witness, not judge, he said, his chapters meant to be laying out evidence. Tales emerged as he did so, shaped by the shadows of his reading, the words that others had used before him to express the spaces of infinite catastrophe: the Black Death and Hell. The canto of Ulysses came unannounced to him one day, while he went with a fellow prisoner to get the day's soup. He recited, grasping the part of Dante he could remember, the stanzas in which a wavering flame fights against a wind. The tongue of fire threw out a voice. It was language. His memory had skipped to the lines:

> Think of your breed; for brutish ignorance
> Your mettle was not made; you were made men,
> To follow after knowledge and excellence.[12]

In the camps, where brutish ignorance came with the soup, it was not clear just what men had become or what their language was. *Survival in Auschwitz* worked to give their descent shape.

Forty years later Levi summed up the experience of the *lager*, the camp, as a gray zone. If he could name it now, he otherwise refused to simplify the experience, resisting the pressure to reduce the knowable to a schema. Nothing about it came to him as the poem had. "The world into which one was precipitated was terrible," he wrote, "yes, but also indecipherable: it did not conform to any model; the enemy was all around but also inside, the 'we' lost its limits, the contenders were not two, one could not discern a single frontier but rather many confused, perhaps innumerable frontiers, which stretched between each of us. One entered hoping at least for the solidarity of one's companions in misfortune, but the hoped for allies, except in special cases, were not there; there were instead a thousand sealed off monads, and between them a desperate covert and continuous struggle."[13] He was describing a remove, another kind of remove, to the other side of life.

"Have you ever read *The Periodic Table*?"

Whiteread asked me the question while her project for a Holocaust memorial on the Judenplatz in Vienna was under way.[14] She had been reading witness testimony by Levi and others since her arrival in Berlin, as if reading could help her make the transition from London, help her to use Berlin as a sketchbook, help produce some understanding of the way the past was traced on the surface of the present there. She had entered the competition for the Vienna memorial in 1995 as a challenge to herself to see if she could take the deathwatch already present in her work to the gray zone; to see if she could take steps in sculpture in the wake of this knowledge; to see if she was capable of casting *toward* it. She had gone to Sachsenhausen three times before she could take a photograph there.[15] She visited other camps. She had been amazed at the way others around her responded, the way kids could picnic on the ovens, the way older people came and broke down. She wanted to see if she could herself make a work that provided a place for grief, and to see if she could make a work, a monument, for thinking these things outright, in public. She too faced the problem of shape.

The *lager*'s gray zone of immorality had spared no one, Levi wrote. People were beaten away from their former humanity to different extents, arriving at, or sliding to, a place somewhere between life and death. "Our manner of living," he would say later, "was not very different from that of donkeys and dogs."[16] Levi hesitated to call many of his fellow inmates men, living men, and hesitated equally to call their death in the gas chambers a death that others might recognize. Those who drowned in the gas molecules, he said, have no story, or rather, the same story: "They followed the slope down to the bottom, like streams that run down to the sea."[17] Nature's analogies provided no one with comfort. The zone was structured, if one can even use that word, by a recurring dream common among those trapped in the *lager*. In the dream the prisoner was free, back in the outside world and trying to communicate what had happened on the inside, but no one believed him.

The first of Levi's books wrote through this dream. The book hoped to puncture and destroy it. Language emerged legible. Increasingly, his testimony became story, an accumulation of stories, the stories of Levi and the people around him, which proceeded, as the people did, through zones—impassive, cruel, grinding, exhausting—where perfect happiness was obviously unrealizable. But so too, Levi learned, was perfect unhappiness, all because, he concluded, the human condition is opposed to everything infinite.[18] On this side of infinity things settled into molecules and monads, and of them he would write.

The stories he kept writing pulled the details forward, containing the record of a time that crossed into another, the time of the reader. They saved something of a

clusion had automatically been drawn. (In that way, it has replaced Clement Greenberg's idea of flatness.) The index is better understood as part of a mimetic procedure.

5. See "Rachel Whiteread in Conversation with Iwona Blazwick," as well as Lynn Barber, "In a Private World of Interiors" (interview), *The Observer Review* (London) Sept. 1, 1996, pp. 7–8, and "Rachel Whiteread Interviewed by Andrea Rose," in Ann Gallagher, ed., *Rachel Whiteread: British Pavilion, 47th Venice Biennale*, exh. cat. (London: British Arts Council, 1997), pp. 29–35. In an interview with David Sylvester, Whiteread explained: "I've spent many hours in the British Museum with Egyptian art," adding that she was about to visit Egypt for the first time. See Sylvester, "Carving Space," *Tate* 17 (spring 1999), p. 42. She also told Rose (p. 33) that the Egyptian collections at the British Museum were important for her. *Valley* (1990), an early bathtub cast, is like a sarcophagus, she told William Furlong in 1992; likewise the documentary on the crypt in Spitalfields was on her mind when she was making the bathtubs. Furlong's interview in *Audio Arts Magazine* 12, no. 1 (1992). Several others have noted the connection to Egyptian sarcophagi and discussed the place of death in her work. See, for example: Sarah Kent, "Cast Rites" (interview), *Time Out London* (June 11–18, 1997), p. 25; Jean-Pierre Criqui, "Rachel Whiteread: Kunsthalle Basel," *Artforum* 33, no. 3 (Nov. 1994), pp. 82–83; Mark Cousins, "Rachel Whiteread: Inside Outcast," *Tate* 10 (winter 1996), pp. 36–41; and Tamar Garb, "Tomb of the Unknown Bather," *Tate* 14 (spring 1998), pp. 34–37. Whiteread put her own views on the matter forward early on. See "Rachel Whiteread in Conversation with Iwona Blazwick," p. 16: "I am trying to preserve something; although I don't think my work is necessarily about death. . . . other cultures celebrate it and we try to brush it under the carpet." To Sylvester, she remarked that there was "lots of real death" in her work (p. 42).

6. "Rachel Whiteread in Conversation with Iwona Blazwick,"

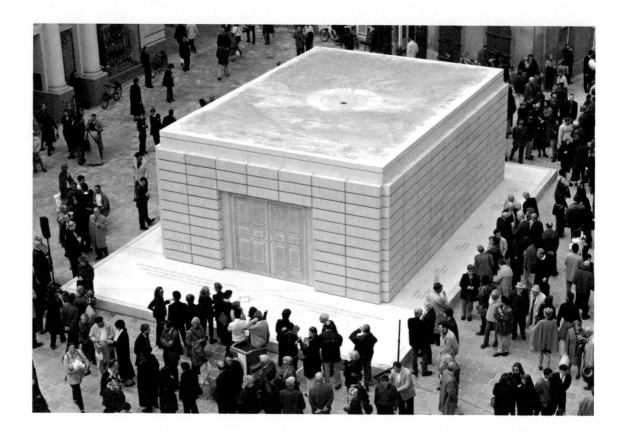

person for another person. They cast characters. This was an exposition, mimesis, a realism. This was not positive conformism, the brand of mimesis that societies regularly use to produce their norms and that, according to Theodor Adorno and Max Horkheimer, had helped unleash modern anti-Semitism.[19] This was a realism of impression, a crafted impression that exposed the nature of historical material as inorganic, tempered by nuance, grounded, and a meeting ground for others. In his later books Levi kept circling back to place this experience into different perspectives, resetting parts of it, like strange stones, into more sagas. His last book, *The Drowned and the Saved*, took its title from a chapter in the first, pulling the old matter back out again into a different language, a different voice, the historian's voice. It took the particular accounts he had written together with books produced by others, to make comparisons and a synthesis that could be used in the late-twentieth-

century discussions of the Holocaust, the discussions of politicians, ethical philosophers, and professors.

The Periodic Table took a much different approach to the truth. Its stories formed a cycle. It turned the discussion of the Holocaust toward the unforgiving essentials of inorganic nature, made it face rock. The results of that confrontation would not produce a synthesis, much less a resolution or conclusion. Its characters were people stepping, episodically, into their circumstances. The truth of materials and the truth of lives rubbed together, neither collapsing into the other. And the *lager*? This book related the gray zone as a story of fire. It told of the attempt by Levi and his friend Alberto to take the cerium rods Levi had stolen from his Auschwitz lab and whittle them down to make cigarette-lighter flints. This fire was metal, not language exactly.[20] Was this the next step after the old flash from Dante? Levi cast out from it; he told other tales of fossil resins, varnishes, and mounds of liverish orange paint. He cast out toward the rest of his life. With these materials, he took literature's version of casting in the direction of the imponderables of sculpture.

With the Vienna memorial, Whiteread worked with many of the same materials, but she could not cast out from the gray zone as Levi had. She did not, she explained in her proposal, expect that these things could be said by her, nor would she presume to speak them for the others. She herself, not being Jewish, only used the summary words "stark" and "raw."[21] Unusually, for her, she chose here to cast the memorial from newly made objects. The material would be concrete. She chose to cast a room, a library this time, turned inside out and sealed shut. With all this, she took her steps toward the gray zone. By casting toward the gray zone, however, she was working to make a sculpture ponderable, to make a work that allowed other people to bring their knowledge of the Nazi labor and extermination camps, their memories of those Jews who had perished there, and their now enlarged sense of a negative human condition. On the base of the memorial, as specified by the program, an inscription honors the memory of the sixty-five thousand Austrian Jews murdered by the Nazis between 1938 and 1945 and the names of the camps to which they had been sent.[22] The memorial was to provide a surface that could offer people a way to honor the dead. Whiteread hoped people would feel compelled to touch it, the way they do religious buildings.[23] This surface pointedly focused, rather than told, the stories of others.

The Judenplatz came with its own stories. It is where in 1789 Mozart wrote his opera *Così fan tutte*. A large statue of Lessing stands nearby. A fifteenth-century relief depicting the baptism of Christ symbolizes, approvingly, the pogrom of 1421.[24] That pogrom, one of the city's bloodiest, led a group of Jews to lock themselves into their

Opposite: Rachel Whiteread,
Holocaust Memorial,
Judenplatz, Vienna, 2000.
Concrete, 3.8 x 7 x 10 m.

p. 11. See also Wright, *Options 46: Rachel Whiteread*, and Ann McFerran, "Relative Values" (interview), *Sunday Times Magazine* (London), Sept. 14, 1997, p. 10.

7. McFerran, "Relative Values," p. 10.

8. "Rachel Whiteread Interviewed by Andrea Rose," p. 29.

9. Ibid.

10. Primo Levi, *The Periodic Table*, trans. Raymond Rosenthal (New York: Schocken Books, 1984), p. 35.

11. See Primo Levi, *The Reawakening*, trans. Stuart Woolf (Boston: Little Brown, 1965). This remembrance was written during the period Dec. 1961–Nov. 1962.

12. Quoted in Primo Levi, *Survival in Auschwitz*, trans. Stuart Woolf (New York: Simon and Schuster, 1993), pp. 112–13.

13. Primo Levi, *The Drowned and the Saved*, trans. Raymond Rosenthal (New York: Random House, 1988), p. 38.

14. Whiteread, in conversation with the author, March 18, 2000.

15. Kent, "Cast Rites," p. 24.

16. Primo Levi, *Moments of Reprieve: A Memoir of Auschwitz*, trans. Ruth Feldman (New York: Simon and Schuster, 1986), p. 13.

17. Levi, *Survival in Auschwitz*, p. 90. See also pp. 121–22.

18. Ibid., p. 17.

19. Theodor Adorno and Max Horkheimer, "Elements of Anti-Semitism," in *Dialectic of Enlightenment*, trans. John Cumming (New York: Continuum, 1972). Literary mimesis has its classic formulation in Erich Auerbach's wartime book, *Mimesis: The Representation of Reality in Western Literature*, trans. Willard R. Trask (Princeton, N.J.: Princeton University Press, 1953). For discussions of ethics and form in relation to anti-Semitism and the Holocaust, see especially: Giorgio Agamben, *Remnants of Auschwitz: The Witness and the Archive*, trans. Daniel Heller-Roazen (Cambridge, Mass.: Zone Books, 1999); Georges Didi-Huberman, "Images malgré tout," in Clément Chéroux, ed., *Mémoires des camps:*

synagogue on the Judenplatz and set themselves alight. Beneath the Vienna memorial the remains of that synagogue have been excavated, and a museum devoted to Jewish life in Vienna has been installed. Whiteread's memorial was to focus all of this too.

An inside comes outside and sits exposed in the Judenplatz. None of its books opens. The books of the library, as if on shelves, line the walls in strict rows. They have been cast in positive and sized like a set, giving the Jews their allegorical figure, for they are the People of the Book. Those coming to look have been given a place: the imaginary position of the library's wall. They become solid inhabitants of another figure, for the wall goes straight to their mind. Then the wall of the memorial breaks into another order on one end. A double door appears. It has been cast completely differently, stopped without explanation on casting's previous, negative, step. Its handles gone—only holes—there is no turning them. This is not a door of the world. It might be the door of dream. Gray and ambiguous, it marks the place that Whiteread's work usually assigns to the viewer: It brings the idea of vision deep into the experience of body; brings vision very close, and lets it sink momentarily, spellbound, into a thing. The mind holds walls, and the wall holds minds.

Can a wall see?

Whiteread kept other projects going while working on the memorial. Different problems, beyond her control, had stalled its construction. In her other projects the dream sights multiplied. Death might be ponderable. Death might be imponderable. But all imponderables would not conjure up death camps necessarily. In her casts she returned to the London imponderables and aggressively experimented with new materials. With just as much energy, she took the book in another direction, casting smaller shelves of books as white plaster negatives.

These new books broke rank again, higgledy-piggledy. Their covers left their impression in color, which bled into the wet plaster and reminded her of watercolor.[25] This left one ragged, almost painted, space stacked above another, and another. She realized, she said, that these floating stacks had been based upon something she knew, "this very sad, dishevelled old library in Hackney that I go past virtually every day. It has a glass frontage with stands out of which these old ladies take their books." But the idea of a book bleeds too, into the sculptor's shapes, shapes that are often considered to be something like language. She continued her reflection for a moment, imagining sculpture to be writing: "As one develops as an artist, the language becomes the language of the pieces you have made previously,

building up a thesaurus, really. A lot of my work is influenced by earlier work, as well as the decrepit libraries of Hackney or the junk shops or the people sleeping in the street, or whatever."[26]

Her book stacks hold echoes of other stacks—a faint note of Donald Judd, for one, there like the flash of Dante, much transformed, barely a reference anymore. Echoes of 1960s American sculpture are often seen in Whiteread's work, and in the eyes of a high Modernist, they drown out everything else. But Bruce Nauman's cast of the negative space under a chair, Carl Andre's floors, Eva Hesse's molds, all come in and out of Whiteread's sculpture, with the other impressions, other shapes and surfaces. One can, she said, see the bookshelves as cliff faces.[27] One can always see doubles and triples, a kaleidoscope in which images turn into other images; the voids and solids conjure. This becomes part of her gesture to others' experience, a way of placing her work together with the experience, of all kinds, of many other people.[28] Whose dream is this? Whose reading? Who speaks? There are so many voices. All stories seem released.

All stories seem released precisely because they are accumulating. Under these conditions, language itself can lose its footing, its capacity for mimetic hold, objective grip. It was this weak side of objectivity that plagued and fascinated Ludwig Wittgenstein, himself a Viennese Jew who had gone to England before World War I, studied philosophy with Bertrand Russell, and eventually stayed there. His philosophical investigations would look at the other side of the objective statement, take it from behind, and see cobwebs growing around all the claims attaching the word to a precise meaning. Were those claims strong? Wittgenstein would look at color and see only that it was impossible to agree upon the meaning of, say, green. While Levi was beginning to write his way out of the gray zone, Wittgenstein wrote too, finishing his *Philosophical Investigations* (1953), which kept historical events away but brought the ordinary sentence into contact with all the deepest human crises of belief and pain. He demonstrated that the word's most ordinary existence was just as riven. He did not tell stories of life and death. Instead, he gave examples, the philosopher's equivalent of the hot-water bottle and the air mattress.

Language was not in and of itself reliable, Wittgenstein showed; it acquired its meaning and gained our trust largely through use.[29] But he felt compelled to demonstrate the graying in everyone's language, the uncertainties, the problems posed when someone tries to speak for someone else. For meanings then—the meaning of someone else's feelings—are half-truths, half-apparent, making it impossible to treat thought empirically, he said at one point, as if it were a gaseous medium.[30] No, it was not. Matter here too came up against language. Since this was philosophy, story gave way

Photographies des camps de concentration et d'extermination nazis, 1933–1999 (Paris: Marvel, 2001), pp. 219–41; Linda Nochlin and Tamar Garb, eds., *The Jew in the Text: Modernity and the Construction of Identity* (London: Thames & Hudson, 1995); and Barbie Zelitzer, ed., *Visual Culture and the Holocaust* (London: Athlone Press, 2001).

20. Levi, *The Periodic Table*, pp. 139–46.

21. Whiteread's proposal for the presentation of her monument on January 23, 1996, contained the following paragraphs:

"All my sculptures in the past have dealt with memory and history, but often in a very oblique way. I never said about any of my sculptures that they 'mean' anything specific (critics of course like to allocate specific meaning to things, a process that is the exact reverse of what I try to do in my work).

I did not come unprepared to the subject of the Holocaust. I spent eighteen months in Berlin in 1992–93. This is a city that is still full of reminders of the Third Reich.... Wherever you turned in Berlin there were stark and raw mementoes of the past. I could not help becoming pre-occupied with the Holocaust then. When I was invited to submit a proposal for Vienna it was a challenging opportunity to return to the subject and apply some of the knowledge I had gained.

I feel daunted by the subject and yet challenged. Having read extensively about the Holocaust (mainly autobiographical texts rather than factual historical accounts) it struck me that it is really a subject beyond comprehension and that any attempts at 'explaining' it are doomed to fail. If art—and sculpture—is expression by other, nonverbal means, then it is a good way of overcoming this verbal deadlock." Quoted in Alfred Stalzer, "Judenplatz Project: An Almost Never-Ending Story," *Perspectiven: Judenplatz: Place of Remembrance* (Vienna), July 6, 2000, p. 96.

22. The technical information regarding the memorial is given in Günter Schweiger, "Construction of the Memorial," *Perspectiven*, p. 100.

23. Whiteread, in conversation with the author, May 15, 2001.

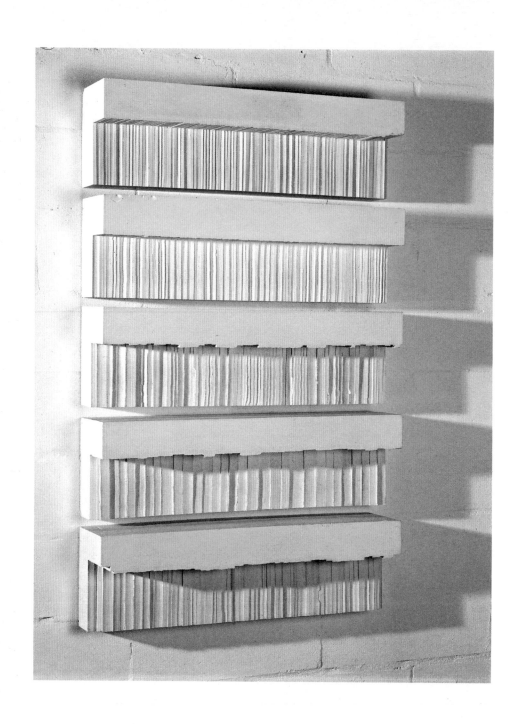

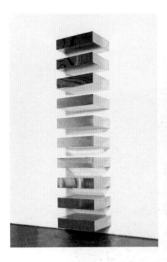

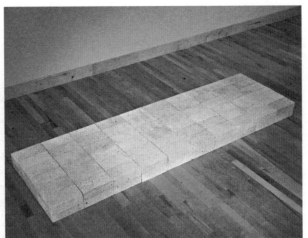

to sentence, and the sentence shone with an eerie light. It flickered. There could be hilarity, but it was going to be dark. Wittgenstein kept his questions coming like bullets.

"When I talk about this table, – am I *remembering* that this object is called a 'table'?"[31]

Whiteread would make tables during these years, plaster tables comparable to those in the committee rooms of Vienna where the decisions about her memorial were being made. She made enameled iron tables pairing casts from a mortuary slab; if one were flipped on top of the other, they would interlock. All of her experience took her casting outward, not toward the gray zone now but complete with the knowledge of it. She was not reading Wittgenstein. She went searching for a new place to live and work and found one, near the Spitalfields church, as it happened. The building needed renovating. It had been a warehouse and before that, a synagogue. When the Guggenheim commission was presented, she decided to take this place with all of its associations—those that were Jewish, those that would be hers and her family's in the future—and cast them toward something unfocused. Three campaigns would begin, to make casts of the two upstairs apartments, casts of the three staircases, and casts of the floor. The Guggenheim's *Untitled (Apartment)* and *Untitled (Basement)* belong to this group.

The imponderables of sculpture share some of the imponderables that lie waiting in language. But what, Wittgenstein wanted to know, does imponderable evidence

Opposite: Rachel Whiteread, *Untitled (Five Shelves)*, 1995–96. Plaster, five units, 25 x 95 x 22.5 cm each. Collection Tom and Charlotte Newby. Above left: Donald Judd, *Untitled*, December 23, 1969. Copper, ten units, 23 x 101.6 x 78.7 cm each; with 23 cm intervals; 434.3 x 101.6 x 78.7 cm overall. Solomon R. Guggenheim Museum, New York, Panza Collection 91.3713.a-.j. Above right: Carl Andre, *Equivalent VIII*, 1966. Firebricks, 12.7 x 68.6 x 22.92 cm. Tate Gallery, London

24. For the Vienna project, see especially: Adrian Searle, "Austere, Silent, and Nameless," *The Guardian* (London), Oct. 26, 2000, p. 5; Euan Ferguson, "Deadly Art of Remembrance" (interview), *The Observer* (London), Oct. 29, 2000, p. 18; and Schweiger, "Construction of the Memorial," p. 25
25. Sylvester, "Carving Space, p. 42.
26. Ibid.
27. Lisa G. Corrin, "A Conversation with Rachel Whiteread," in Corrin, Patrick Elliott, and Andrea Schlieker, *Rachel Whiteread*, exh. cat. (Edinburgh: National Galleries of Scotland; London: Serpentine

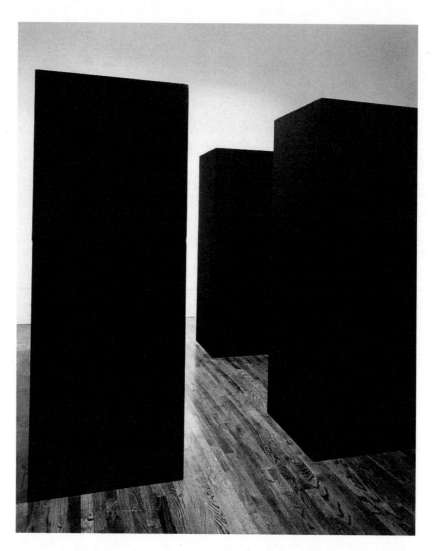

accomplish? He spoke of its subtleties, those of glance and gesture and tone. He gave as an example the genuinely loving look, distinguishing it from the pretend one, and said that he might well be unable to describe the difference, but this not for a lack of words.[32]

His investigations were coming to an end. Although he would leave language to hover, in the end gored and moved by forms of life, he would not abandon his long work on language, his view of its other side. *Philosophical Investigations* ended with more examples, many of them involving how to understand not only things but impressions of things. The examples were made to keep hitting obstacles. They were not brought in to resolve all the earlier questions.

"Does what is ordinary always make the *impression* of ordinariness?"[33]

At the end of the *Investigations*, Wittgenstein turned to face the kaleidoscopic shimmer in sight. He attacked the impressions that came with perception. They were similar to the phenomena he had already treated. The movement in certain outline figures gave him examples to introduce. He took a picture of a step and pierced it with a line.[34] The step nonetheless kept its two aspects, although neither one could be seen at exactly the same time as the other. The step was convex. The step was concave. But not both at once. This is the movement that all Whiteread's negative casts exploit. This is the movement we stare at. Her molds give a positive image as well as a negative image of the absent object but not both together. The negatives give us different associations but not all together. Matter is shown expanding. Her impression gives off impressions. This is the sight for the mind. But can a mind hold it?

The synagogue from which she has been casting has had its own wartime experience. It was rebuilt in the mid-1950s on the site of an older synagogue that had been destroyed in 1941 in the blitz. It contained the life of a group of people: Jews in England, the immigrants, the refugees and the natives; it was their place for Hebrew classes, worship, a youth club, a ladies' guild, a ladies' balcony. One kind of life replaced another in this place. The new synagogue, after thirty years, closed down and was used as a warehouse for plywood and then for textiles.[35] The casts from it express a life that might have passed through the gray zone, but they gesture out to the world of the elements. It is a world of pieces, objects, monads, gaseous media. Whiteread has cast it in parts.

First, there are the domestic spaces of the synagogue, which were small living rooms for the rabbi and the caretaker, making of them cubes that sit apart from one another like pieces of a puzzle that will not quite fit. In between them, interrupting,

Opposite left: Diagram of a pierced step, from Ludwig Wittgenstein's *Philosophical Investigations*, 1953. Opposite right: Tony Smith, *The Maze*, 1967 (destroyed). Painted steel, four units total; two units: 203.2 x 304.8 x 76.2 cm; two units: 203.2 x 152.4 x 76.2 cm. Installation view (plywood re-creation) at Paula Cooper Gallery, New York, 1987. Above: Rachel Whiteread, *Untitled*, 1995. Correction fluid on black paper, 29.5 x 8.5 cm. Collection of the artist

Gallery, 2001), p. 24.
28. For the discussion of Whiteread's relation to Minimalism, see: Rosalind Krauss, "Rachel Whiteread: Making Space Matter," *Tate* 10 (winter 1996), pp. 32–36; Briony Fer's postscript to her book *On Abstract Art* (New Haven: Yale University Press, 1997), pp. 162ff.; Fer's article "Treading Blindly, or the Excessive Presence of the Object," *Art History* 20, no. 2 (June 1997), pp. 268–88; and Alex Potts, *The Sculptural Imagination* (New Haven: Yale University Press, 2000). The classic, benchmark discussion of

comes the void of their walls. These flats, not flat, have moved the idea of the wall that Whiteread had established before. Still pristinely cast, these walls now move inside the blocks and slip down through cracks where no human can go. They are white. They are far. They make a maze that escapes. They hold their ghosts, the ghost of a destroyed Tony Smith *Maze* (1967) of black monoliths, the ghost of raw marble. For these pieces, she used a robust, plasticized plaster specially developed for the Walt Disney Company for making fake rock faces.[36] Which rock? Two years before she had spoken with David Sylvester about the spaces in the quarry at Carrara, where everything, she said, is white, "massive white lumps, as big as this room." She had gone into the side of the mountain, the source of those great rocks. There were the voids, "phenomenal caverns," she went on, "just completely surrounded by marble. They were just beautiful. It's amazing taking stuff like that out of the earth in that way." A little later she asked Sylvester, "Tony Smith—do you like his work?"[37] She had just seen a summer exhibition of his sculptures in New York. Black lived in her mind, along with the white.

> Were these rooms?
> Were they plaster?

Plaster is a very warm material, she has said.[38] She has also described it as fragile, dense, inert.[39] Whiteread has often made her materials embody confusions and hence movements: Here plaster acts as marble, but there have also been plastic as anthracite, iron as rubber, rubber neoprene as beeswax, fiberglass rubber as pitch, and polyester resin as water. This accompanies the doubling already present in the cast impression and in the shapes, the reproduction of someone else's experience, the residue of use, all mimesis expanding.

The stairs, Whiteread said, proceed from her corridor work. She had long wanted to cast them. They echo aspects of Andre's floors and Nauman's corridors, but these are aspects, one form, Wittgenstein would say, of "seeing-as." Pierce them. The stairs in *Basement* lie belly down along the floor, squared, sheer surfaces that turn and rear up. Steps run along a side. They must be convex. They must be concave.

Whiteread worked for a while on the idea by drawing it, letting a staircase rise and fall as a function of the outlines and ground lines she drew for it, letting its image move into black and, at the same time, appear against white. She returned to the idea by blacking out the stairs on old black-and-white postcards, turning a positive into the image of a photographic negative, floating a monument. She remembered her own photographs, the stairs at Sachsenhausen leading down to the ovens. For the first

Opposite left: Rachel Whiteread, *Untitled*, 2000. Ink on postcard, 13.5 x 8.5 cm. Collection of the artist. Opposite right: Tony Smith, *The Snake Is Out*, 1962 (fabricated 1981). Painted steel, 457.2 x 706.1 x 574 cm. The Patsy R. and Raymond D. Nasher Collection, Dallas, Texas

Minimalism per se appears in Rosalind Krauss, *Passages in Modern Sculpture* (New York: Viking Press, 1977).
29. Ludwig Wittgenstein, *Philosophical Investigations*, trans. G. E. M. Anscombe (Oxford: Basil Blackwell, 1953), p. 20. For the best account of Wittgenstein's years before and during the war, see Ray Monk, *Ludwig Wittgenstein: The Duty of Genius* (Harmondsworth: Penguin Books, 1990).
30. Wittgenstein, *Philosophical Investigations*, p. 47.
31. Ibid., p. 157.
32. Ibid., p. 228.
33. Ibid., p. 156.
34. Ibid., p. 203. The perceptual inversions Wittgenstein studied were also the material of the Gestalt psychologists. In the 1960s many artists would begin to use these figures openly. For a discussion of this work in relation to the art of Robert Smithson, see the forthcoming book by Ann Reynolds, *Robert Smithson: Learning from Las Vegas and Elsewhere* (Cambridge, Mass.: MIT Press).
35. See the accounts of the history of the Bethnal Green Great Synagogue as given in the local papers: "Reopening of Blitzed Synagogue," *Hackney Gazette* (London), July 16, 1958; and "Synagogue Closing," *Jewish Chronicle* (London), Aug. 31, 1984.
36. Adrian Searle, "Visual Arts: Making Memories, Rachel Whiteread's Work," *The Guardian* (London), Oct. 17, 2000.
37. Sylvester, "Carving Space," p.45.
38. Furlong, interview with Whiteread.
39. Wright, *Options 46: Rachel Whiteread*.
40. Levi, *The Reawakening*, p. 52.
41. Levi, *The Periodic Table*, p. 232.

time she made small models, rough wooden forms in order to visualize the full complexity of the end result. She realized as she held the models that these casts could be turned, that the stair casts could lose their sense of direction and still have options. They could sit on one of their sides or another. These steps become light ones. They exist at the scale of Smith's large sculptures; they produce a white echo to his *The Snake Is Out* (1962). But what *do* these impressions accomplish?

They move. This time the movement is not spirited off or buried; it lifts above ground. The dark patches show how the stairs were once walked, but these are no ordinary stairs despite that impression. They are negatives that keep the positive images lingering longer. They provide the most concrete image yet for casting toward something else. They will cross the Deutsche Guggenheim Berlin and move on. There will be new stories coming to join the old, histories riding together with art histories. Casting makes steps that do not stop. "It is common knowledge that nobody is born with a decalogue already formed," Levi wrote, "but that everyone builds his own either during his life or at the end, on the basis of his own experiences, or of those of others which can be assimilated to his own; so that everybody's moral universe, suitably interpreted, comes to be identified with the sum of his former experiences, and so represents an abridged form of his biography."[40] A cast too can shorten a story and still hold something of lives.

A cast is a bridge.

Levi drew *The Periodic Table* to an end by telling the story of carbon. He was fulfilling his childhood dream of telling the life of an atom. Carbon, the carrier of organic life, moved through many, many states. Matter materialized, decayed, flew. Yet the cycle of life defies the storyteller. Levi knew this and confessed that the storyteller's "theme is desperate, his means feeble, and the trade of clothing facts in words is bound by its very nature to fail."[41]

The stairs do not yet have the reach of carbon, unfortunately. They can only release impressions from an impression, just as before. And yet they possess something of carbon's optimism. They stay open. They pleat the plaster like an accordion or a ziggurat. They let a mimetic procedure show how far it can make matter go. Like Levi, like Wittgenstein, Whiteread is a realist. We come up from the basement. Mimesis has brought us upstairs. Some things are simple. We can stay here.

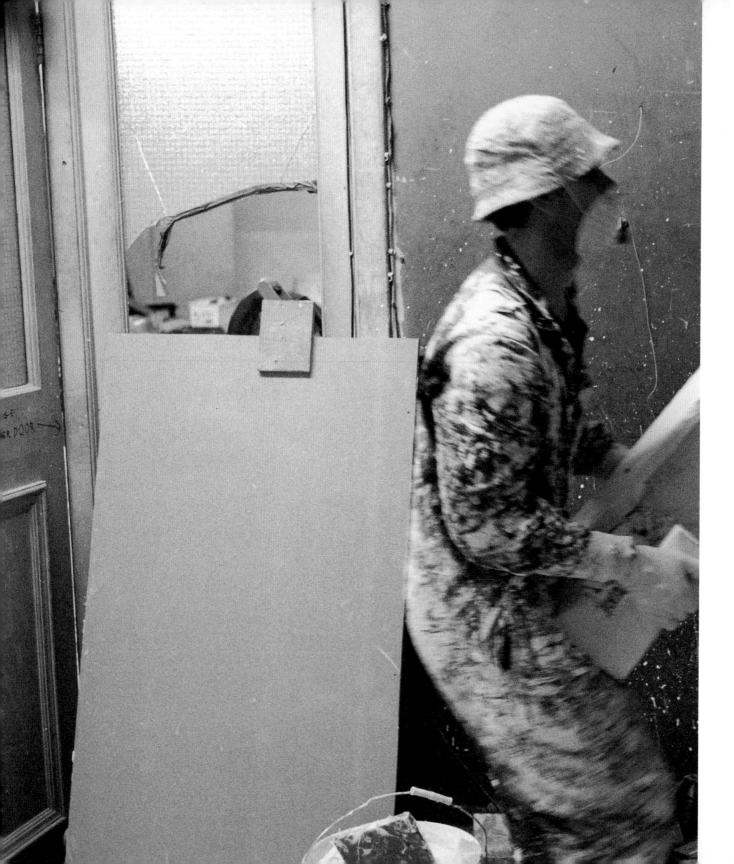

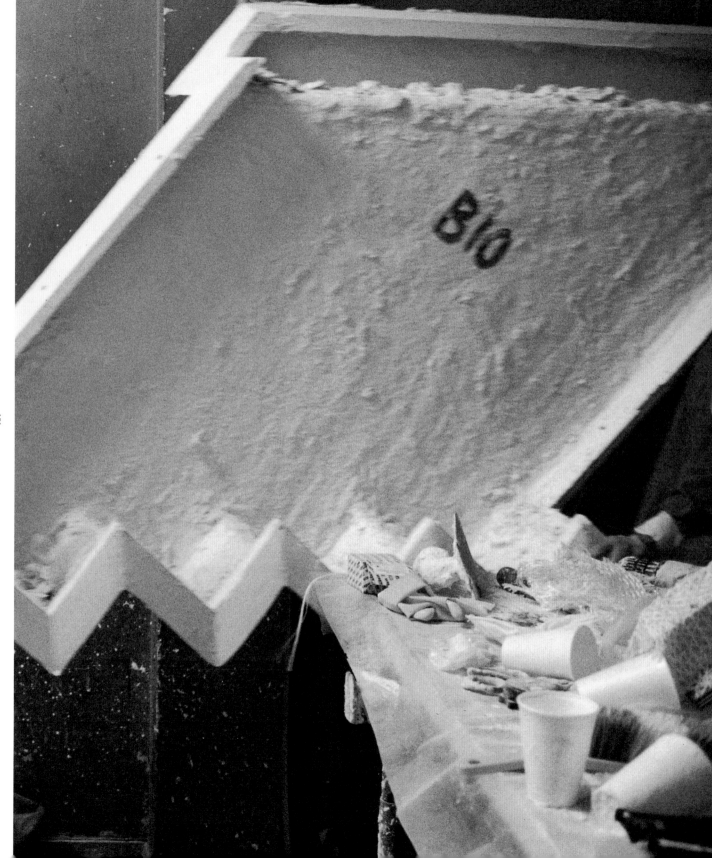

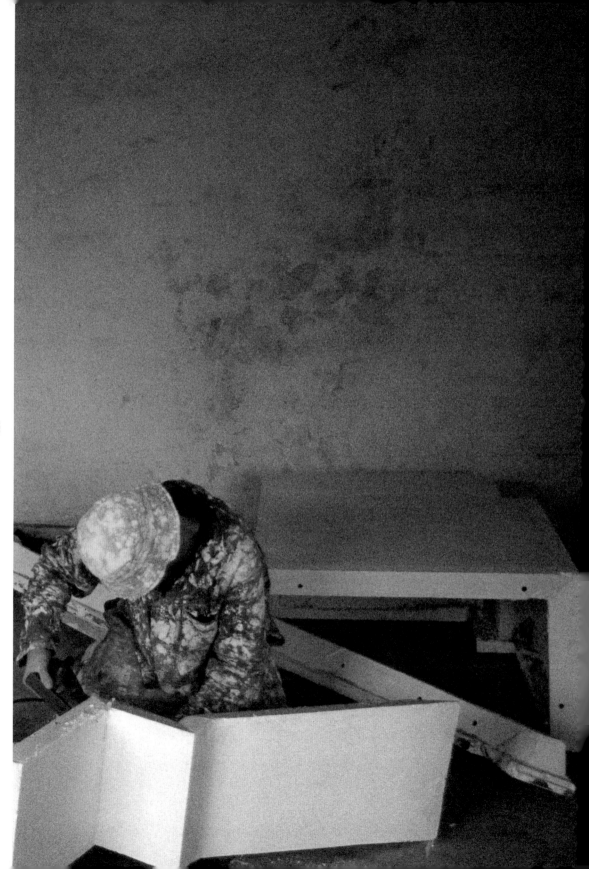

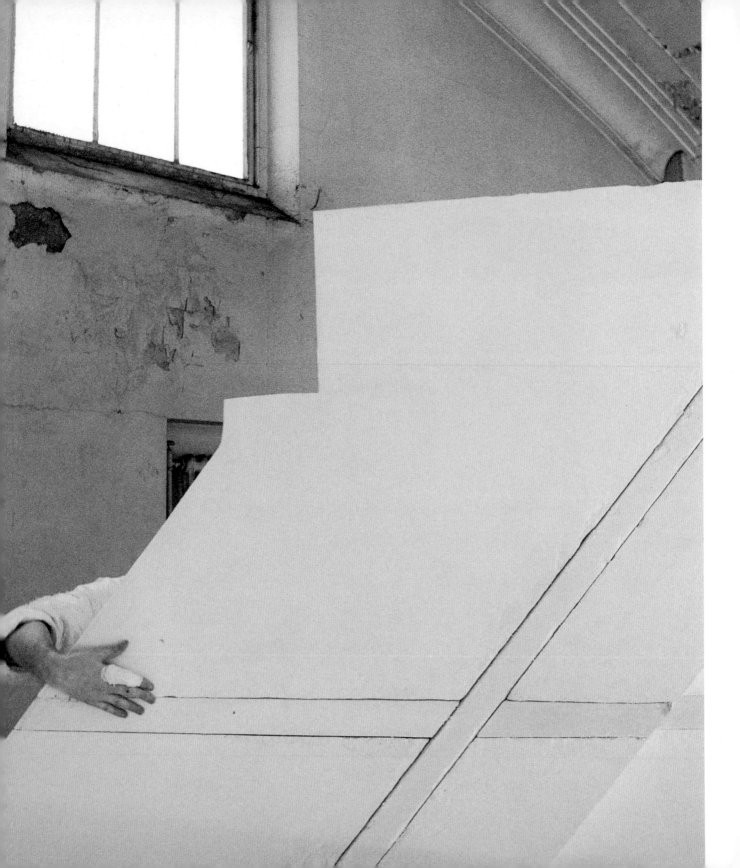

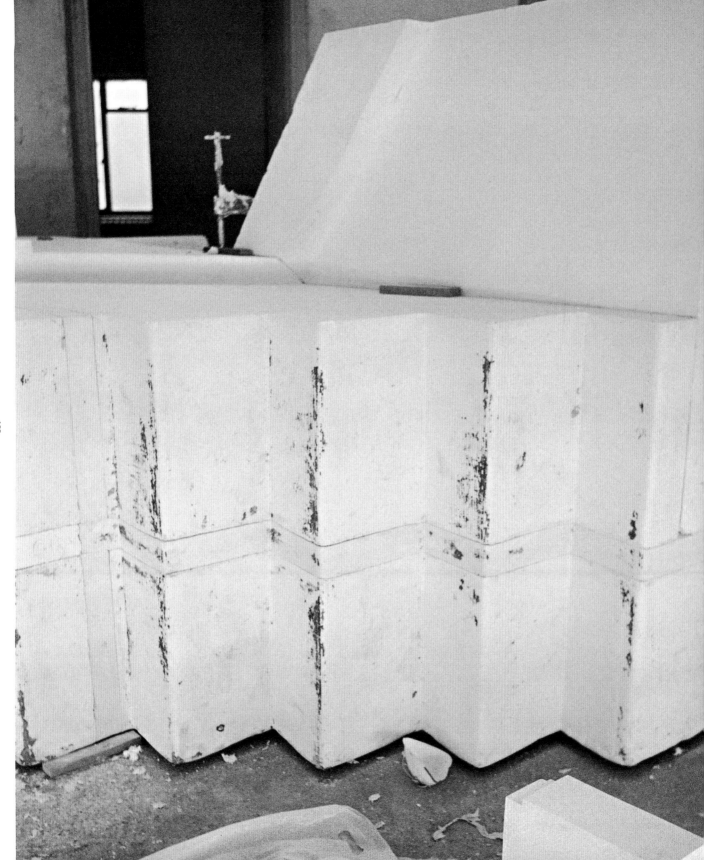

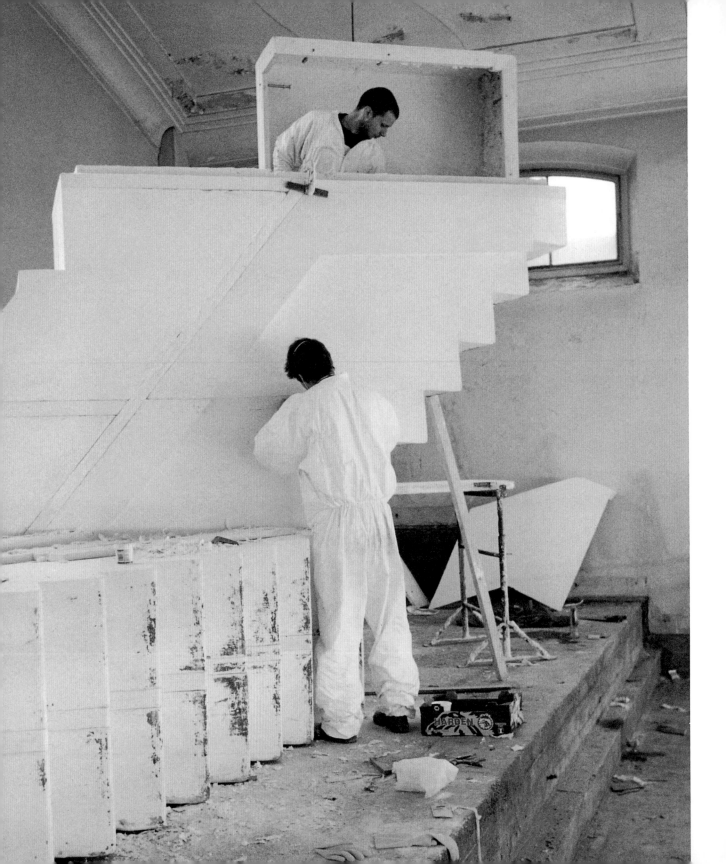

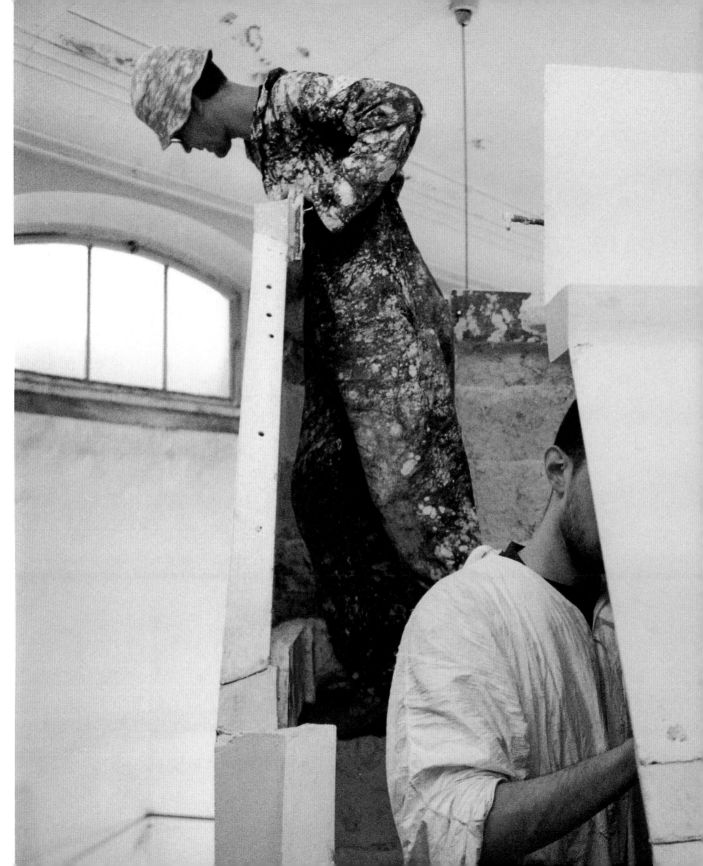

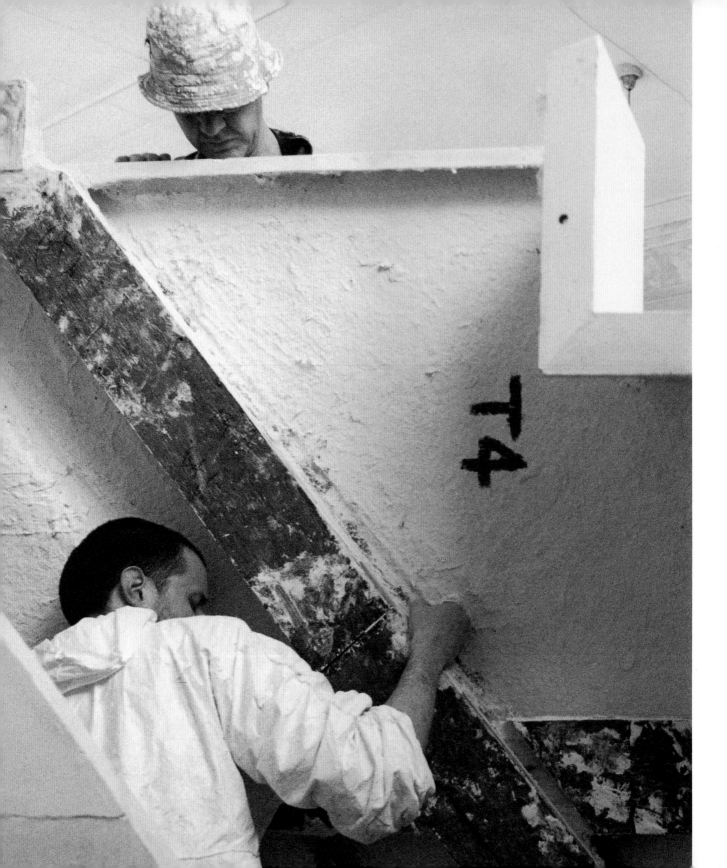

Select Exhibition History
Exhibition entries contain information about accompanying exhibition catalogues and are followed by related articles and reviews.

Solo Exhibitions
1988
Carlisle Gallery, London, Nov.

1990
Chisenhale Gallery, London, *Ghost*, June 13–July 17. Traveled to Arnolfini Gallery, Bristol, Jan. 13–Feb. 7, 1991.
Brooks, Liz. "Rachel Whiteread, Chisenhale." *Artscribe* (London), no. 84 (Nov.–Dec. 1990), p. 80.
Graham-Dixon, Andrew. "An Artist's Impression." *The Independent* (London), July 3, 1990, p. 11.
Renton, Andrew. "Rachel Whiteread, Chisenhale." *Flash Art* (Milan) 23, no. 154 (Oct. 1990), pp. 158–59.

1991
Karsten Schubert Ltd, London, *Rachel Whiteread, Sculpture*, Feb. 28–March 23.
Barter, Ruth. "England in Review." *Arts Magazine* (New York) 65, no. 10 (summer 1991), pp. 103–05.
Beaumont, Mary Rose. "Rachel Whiteread, Karsten Schubert Ltd." *Arts Review* (London), March 8, 1991, p. 117.

1992
Luhring Augustine Gallery, New York, *Rachel Whiteread: Recent Sculpture*, Jan. 11–Feb. 8.
Melrod, George. "Rachel Whiteread, Luhring Augustine." *Artnews* (New York) 91, no. 5 (May 1992), p. 131.
Smith, Roberta. "Rachel Whiteread, Luhring Augustine." *The New York Times*, Jan. 17, 1992, p. C28.
Taplin, Robert. "Rachel Whiteread at Luhring Augustine." *Art in America* (New York) 80, no. 9 (Sept. 1992), p. 124.
Fundació "la Caixa," Sala Montacada,

Barcelona, *Rachel Whiteread: Escultures*, May 8–June 7. Exh. cat., with text by Jorge Luis Marzo (in English, Catalan, and Spanish).

Stedelijk van Abbemuseum, Eindhoven, The Netherlands, *Rachel Whiteread*, Dec. 4, 1992–Jan. 31, 1993. Exh. cat., with texts by Jan Debbaut, Selma Klein Essink, and Stuart Morgan and interview by Iwona Blazwick.
Van Veelen, Ijsbrand. "Rachel Whiteread, Van Abbemuseum, Eindhoven." *Flash Art* (Milan) 26, no. 170 (May–June 1993), p. 122.

1993
Galerie Claire Burrus, Paris, *Rachel Whiteread*, May 13–July 9.

Museum of Contemporary Art, Chicago, *Rachel Whiteread: Sculptures*, July 10–Sept. 26.
Hixson, Kathryn. "Rachel Whiteread, MCA." *Flash Art* (Milan) 27, no. 174 (Jan.–Feb. 1994), p. 100.
Yood, James. "Rachel Whiteread, Museum of Contemporary Art." *Artforum* (New York) 32, no. 5 (Jan. 1994), p. 94.

DAAD Galerie, Berlin, *Rachel Whiteread–Gouachen*, Nov. 5–Dec. 5. Exh. cat., with text by Friedrich Meschede (in English and German).

1994
Galerie Aurel Scheibler, Cologne, *Rachel Whiteread: Works on Paper*, Feb. 28–April 23.
Eickhoff, Beate. "Unsichtbares sichtbar machen." *Kölner Stadt-Anzeiger* (Cologne), April 2, 1994.

Kunsthalle Basel, *Skulpturen/Sculptures*, Aug. 21–Oct. 30. Traveled to Institute of Contemporary Art, University of Pennsylvania, Philadelphia, Feb. 3–April 26, 1995, and The Institute of Contemporary Art, Boston, May 9–July 9, 1995. Exh. cat.,

with text by Christoph Grunenberg (in English and German).

Cohen, Joyce. "The Institute of Contemporary Art/Boston: Rachel Whiteread, Sculpture." *Art New England* (Newtonville, Mass.) 16 (Aug.–Sept. 1995), pp. 62–63.

Cooke, Lynne. "Rachel Whiteread." *Burlington Magazine* (London) 137, no. 1105 (April 1995), pp. 273–74.

Criqui, Jean-Pierre. "Rachel Whiteread, Kunsthalle, Basel." *Artforum* (New York) 33, no. 3 (Nov. 1994), pp. 82–83.

Pfütze, Hermann. "Rachel Whiteread." *Kunstforum International* (Mainz, Germany), no. 128 (Oct.–Dec. 1994), pp. 373–75.

Stein, Judith E. "Rachel Whiteread, Institute of Contemporary Art." *Artnews* (New York) 94, no. 6 (summer 1995), pp. 133–34.

Temin, Christine. "Rachel Whiteread Brings Her Investigations to Boston." *The Boston Sunday Globe*, May 7, 1995, pp. 33, 38–39.

Luhring Augustine Gallery, New York, *Rachel Whiteread: Drawings*, Sept. 10–Oct. 8.

1995
The British School at Rome, Italy, *Rachel Whiteread: Sculpture*, Feb. 10–March 21.

Karsten Schubert Ltd, London, *Rachel Whiteread: Untitled (Floor)*, May 16–June 24.

Searle, Adrian. "The Artist Who Broke the Mould." *The Independent* (London), May 16, 1995, p. 20.

1996
Karsten Schubert Ltd, London, *Rachel Whiteread: Demolished*, April 17–May 11.

Luhring Augustine Gallery, New York, *Rachel Whiteread*, May 7–June 18.

Kimmelman, Michael. "Rachel Whiteread." *The New York Times*, May 17, 1996, p. C24.

Liotta, Christine. "Rachel Whiteread." *Sculpture* (Washington, D.C.) 15, no. 7 (Sept. 1996), p. 65.

Tate Gallery, Liverpool, *Rachel Whiteread: Shedding Life*, Sept. 13, 1996–Jan. 5, 1997. Traveled to Palacio de Velazquez, Museo Nacional Centro de Arte Reina Sofía, Madrid, *Rachel Whiteread*, Feb. 11–April 22, 1997. Exh. cat., with texts by Fiona Bradley, Rosalind Krauss, Bartomeu Marí, Stuart Morgan, and Michael Tarantino (English and Spanish editions).

Batchelor, David. "Rachel Whiteread." *Burlington Magazine* (London) 138, no. 1125 (Dec. 1996), pp. 837–38.

Bevan, Roger. "The Safe Art of Exhibitions and Unsafe Art of Memorials." *The Art Newspaper* (London) 7, no. 62 (Sept. 1996), p. 20.

Feaver, William. "Rachel Whiteread." *Artnews* (New York) 95, no. 11 (Dec. 1996), pp. 128–29.

Greenberry, Astrid. "Traditional, Banal and Quirky." *Make* (London), no. 73 (Dec. 1996–Jan. 1997), p. 21.

Hilton, Tim. "Of Innocence and Experience." *The Independent* (London), Sept. 22, 1996, p. 24.

Lambirth, Andrew. "Solid Space." *The Spectator* (London), Oct. 12, 1996, p. 60.

Morrissey, Simon. "Cast Spaces that Recall the Past." *Architects' Journal* (London), Oct. 31, 1996, p. 61.

Searle, Adrian. "World of Interiors." *The Guardian: G2* (London), Sept. 17, 1996, pp. 10–11.

Whitfield, Sarah. "The Private Life of Hot-Water Bottles: Rachel Whiteread at the Tate." *New Statesman* (London), Sept. 20, 1996, pp. 41–43.

Max Gandolph-Bibliothek, Salzburg, Mar. 30–Apr. 17, 1996, and Herbert von Karajan Centrum, Vienna, Apr. 26–May 14, 1996, *Rachel Whiteread: Sculptures 1988–96* (Prix Eliette von Karajan). Exh.cat., with texts by Dietgard Grimmer, Lóránd Hegyi, and Harald Szeemann (in English and German).

1997
British Pavilion, Venice, *Rachel Whiteread* (part of 47th Venice Biennale), June 15–Nov. 9. Exh. cat., with texts by Ann Gallagher and Andrea Rose (in English and Italian).

Bickers, Patricia. "Last Exit to Venice." *Art Monthly* (London), no. 208 (July–Aug. 1997), pp. 1–5.

1998
Anthony d'Offay Gallery, London, *Rachel Whiteread*, Oct. 29, 1998–Jan. 16, 1999. Exh. cat., with text by A. M. Homes.

Field, Marcus. "Feeding Frenzy." *Blueprint* (London), no. 156 (Dec. 1998), p. 50.

Godfrey, Tony. "Rachel Whiteread." *Burlington Magazine* (London) 141, no. 1150 (Jan. 1999), p. 50.

1999
Luhring Augustine Gallery, New York, *Rachel Whiteread*, Oct. 30–Dec. 18.

Saltz, Jerry. "A Great Public Artist Is Diminished Indoors–Material Girl." *The Village Voice* (New York), Nov. 16, 1999, p. 79.

Schwendener, Martha. "Rachel Whiteread." *Time Out* (New York), Dec. 16, 1999, p. 117.

2000
Luhring Augustine Gallery, New York, *Water Tower Drawings*, Sept. 9–Oct. 14.

2001
Serpentine Gallery, London, *Rachel Whiteread*, June 20–Aug. 5. Traveled to Scottish National Gallery of Modern Art,

Edinburgh, Sept. 29–Dec. 9. Exh. cat., with texts by Lisa G. Corrin, Patrick Elliott, and Andrea Schlieker.

Aidin, Rose. "A Sculptor Who Casts a Long Shadow." *The Sunday Telegraph* (London), June 17, 2001, Section 5, Arts, p. 1.

Beechey, James. "Materials Girl." *Financial Times Weekend* (London), June 16, 2001, pp. 16–19, 34.

Bishop, Claire. "Cool Steps to Star Status." *Evening Standard* (London), June 26, 2001, p. 48.

Cork, Richard. "Transfixed by Baleful Stairs." *The Times: Times 2* (London), June 27, 2001, pp. 15–17.

Mullins, Charlotte. "Exposed: The Space Beneath the Stairs." *The Independent on Sunday* (London), June 17, 2001, p. 10.

Searle, Adrian. "The Cast Show." *The Guardian: G2* (London), June 19, 2001, pp. 12–13.

Stringer, Robin. "Rachel Whiteread Steps Back to Where It All Began." *Evening Standard* (London), June 20, 2001, p. 27.

Public Projects
1993
House (commissioned by Artangel Trust), 193 Grove Road, London, Oct. 25, 1993–Jan. 11, 1994.

Cohen, David. "London, England." *Sculpture* (Washington, D.C.) 13, no. 2 (March–April 1994), pp. 52–53.

Dalley, Jan. "The Broader Picture: The World Turned Inside Out." *The Independent* (London), Oct. 24, 1993, p. 52.

Exnir, Julian. "Das Meisterwerk wird abgerissen." *Die Tageszeitung* (Berlin), Nov. 30, 1993.

Feaver, William. "Rachel Whiteread, Artangel Trust." *Artnews* (New York) 93, no. 3 (March 1994), p. 148.

Graham-Dixon, Andrew. "This Is the House that Rachel Built." *The Independent* (London), Nov. 2, 1993, Section 2, p. 25.

McEwan, John. "The House that Rachel Unbuilt." *The Sunday Telegraph* (London), Oct. 24, 1993, p. 6.

Shone, Richard. "Rachel Whiteread's 'House.'" *Burlington Magazine* (London) 135, no. 1089 (Dec. 1993), pp. 837–38.

1998
Water Tower (commissioned by Public Art Fund), rooftop, West Broadway at Grand Street, New York, June 7, 1998–Oct. 27, 2000.

Carr, C. "Going Up in Public." *The Village Voice* (New York), June 23, 1998, p. 72.

Harris, Jane. "Rachel Whiteread: Sponsored by the Public Art Fund." *Sculpture* (Washington, D.C.) 18, no. 1 (Jan.–Feb. 1999), pp. 65–66.

Jodidio, Philip. "Eau Art." *Connaissance des Arts* (Paris), no. 553 (Sept. 1998), pp. 142–43.

Shone, Richard. "Eyes on the Skies." *Artforum* (New York) 36, no. 5 (Jan. 1998), p. 34.

Vogel, Carol. "A Water Tower for Peace." *The New York Times*, Jan. 13, 1998, p. E34.

Vogel, Carol. "SoHo Site Specific: On the Roof." *The New York Times*, June 11, 1998, pp. E1, E4.

2000
Holocaust Memorial, Judenplatz, Vienna, unveiled Oct. 26, 2000.

Bevan, Roger. "Rachel Whiteread for Holocaust Memorial." *Art Newspaper* (London) 7 (March 1996), p. 2.

Cash, Stephanie. "Holocaust Memorial Delayed." *Art in America* (New York) 84, no. 12 (Dec. 1996), p. 23.

Connolly, Kate. "Closed Books and Stilled Lives." *The Guardian* (London), Oct. 26, 2000, p. 5.

Ferguson, Euan. "Deadly Art of Remembrance: The Sculptor's Memorial in Vienna to Holocaust Victims Has Been Unveiled–But It Took Her Five Years of 'Hell and Torment.'" *The Observer* (London), Oct. 29, 2000, p. 18.

Kastner, Jeffrey. "A Compromise for Vienna's Holocaust Memorial." *Artnews* (New York) 97, no. 4 (April 1998), p. 88.

Kimmelman, Michael. "How Public Art Turns Political." *The New York Times*, Oct. 28, 1996, pp. C15, C18.

Kimmelman, Michael. "Behind Sealed Doors, Opening Up the Past." *The New York Times*, Oct. 30, 2000, p. E1.

Searle, Adrian. "Making Memories: Rachel Whiteread's Work." *The Guardian* (London), Oct. 17, 2000, p. 12.

Searle, Adrian. "Austere, Silent and Nameless–Whiteread's Concrete Tribute to Victims of Nazism." *The Guardian* (London), Oct. 26, 2000, p. 5.

2001
Monument, Fourth Plinth, Trafalgar Square, London, unveiled June 4 (closing date to be determined for 2002).

Barber, Lynn. "Someday, My Plinth Will Come." *The Observer Magazine* (London), May 27, 2001, pp. 30–35.

Cork, Richard. "Now for the Rachel Capers." *The Times: Times 2* (London), June 1, 2001, pp. 16–17.

Cork, Richard. "Space Craft." *The Times* (London), June 2, 2001, p. 1F.

Freeman, Hadley. "What Sculpture? That Glass Thing?" *The Guardian: G2* (London), June 6, 2001, pp. 16–17.

Hall, James. "Short of Statue." *Artforum* (New York) 38, no. 3 (Nov. 1999), p. 47.

Kennedy, Maev. "Acclaim Greets Trafalgar Square Sculpture." *The Guardian* (London), June 5, 2001, p. 5.

Muir, Robin. "Rachel Whiteread Is Famous for Making Casts of Everything from an Old Bath to a Terraced House. But Now She's Taken on Her Most Challenging Project Yet: A New Monument for Trafalgar Square." *The Independent Magazine* (London), May 26, 2001, pp. 15–20.

Searle, Adrian. "Whiteread's Reminder of Modernist Ideals Defies Sentimentality." *The Guardian* (London), June 5, 2001, p. 5.

Sutcliffe, Thomas. "Some Day My Plinth Will Come (But Only Just)." *The Independent* (London), June 5, 2001, p. 5.

Usherwood, Paul. "Situation Vacant." *Art Monthly* (London), no. 222 (Dec. 1998–Jan. 1999), pp. 13–15.

Select Bibliography

For exhibition catalogues and reviews, see the exhibition history.

Books

Lingwood, James, ed. *Rachel Whiteread: House*. London: Phaidon Press, 1995.

Neri, Louise, ed. *Looking Up: Rachel Whiteread's Water Tower*. New York: Public Art Fund and Scalo Publishers, 1999.

Wiesenthal, Simon, ed. *Projekt: Judenplatz Wien*. Vienna: Paul Zsolnay Verlag, 2000.

Articles and Essays

Archer, Michael. "Ghost Meat." *Artscribe* (London), no. 87 (summer 1991), pp. 35–38.

Barnes, Rachel. "No More House Work: With *House*, Rachel Whiteread Joined Politics, Art and Anger." *The Guardian* (London), April 8, 1995, p. 28.

Benezra, Neal. "Rachel Whiteread: A Sense of Silence." In Benezra and Olga M. Viso, *Distemper: Dissonant Themes in the Art of the 1990s*, exh. cat. Washington, D.C.: Smithsonian Institution, Hirshhorn Museum and Sculpture Garden, 1996, pp. 104–14.

Buck, Louisa. "Rachel Whiteread's Space Craft." *The Connoisseur* (New York) 221, no. 956 (Dec. 1991), p. 109.

Burton, Jane. "Concrete Poetry." *Artnews* (New York) 98, no. 5 (May 1999), pp. 154–57.

Cash, Stephanie. "A Tower Is Born." *Art in America* (New York) 87, no. 4 (April 1999), p. 107.

Choon, Angela. "Rebels of the Realm." *Art and Antiques* (New York) 17, no. 4 (April 1994), pp. 56–63.

Comay, Rebecca. "Memory Block: Rachel Whiteread's Proposal for a Holocaust Memorial in Vienna." *Art and Design* (London) 12, no. 11–12 (July–Aug. 1997), pp. 64–75.

Cousins, Mark. "Inside Outcast." *Tate* (London), no. 10 (winter 1996), pp. 36–41.

Fairbrother, Trevor. "Whiteread's Ghost." *Parkett* (Zurich), no. 42 (Dec. 1994), pp. 90–95.

Fer, Briony. "Treading Blindly, or The Excessive Presence of the Object." *Art History* (Malden, Mass.) 20, no. 2 (June 1997), pp. 268–86.

Hattenstone, Simon. "From House to Holocaust; Controversial Sculptor Rachel Whiteread Talks to Simon Hattenstone." *The Guardian* (London), May 31, 1997, p. 3.

Kastner, Jeffrey. "Bad Housekeeping." *Artnews* (New York) 93, no. 2 (Feb. 1994), p. 47.

Kent, Sarah. "Rachel Whiteread." *Modern Painters* (London) 5, no. 2 (summer 1992), pp. 86–87.

Krauss, Rosalind. "Making Space Matter." *Tate* (London), no. 10 (winter 1996), pp. 33–36.

Lubbock, Tom. "The Shape of Things Gone." *Modern Painters* (London) 10, no. 3 (autumn 1997), pp. 34–37.

Massey, Doreen. "Space-Time and the Politics of Location." *Architectural Design* (London) 68 (March–April 1998), pp. 34–38.

Morgan, Stuart. "Rachel Whiteread: La Melancolie des moulages." *Art Press* (Paris), no. 172 (Sept. 1992), pp. 37–40.

——. "Rachel Whiteread." *Artnews* (New York) 92, no. 9 (Nov. 1993), pp. 127–28.

——. "Rachel Whiteread: Inside Out." In *What the Butler Saw: Selected Writings by Stuart Morgan*. London: Durian, 1996, pp. 254–56.

Nixon, Mignon. "Bad Enough Mother." *October* (Cambridge, Mass.), no. 71 (winter 1995), pp. 71–92.

Phillips, Patricia C. "Making Memories." *Sculpture* (Washington, D.C.) 16, no. 3 (March 1997), pp. 22–27.

Pietsch, Hans. "Rachel Whiteread: Der Blick ins Innere der Dinge." *Art* (Hamburg), no. 2 (Feb. 1999), pp. 46–55.

Princenthal, Nancy. "All That Is Solid." *Art in America* (New York) 83, no. 7 (July 1995), pp. 52–57.

Renton, Andrew. "Rachel Whiteread: A Song from Under the Floorboards." *Art and Text* (Sydney), no. 47 (Jan. 1994), pp. 54–59.

Rudolph, Karen. "Rachel Whiteread." *Beaux Arts Magazine* (Paris), no. 132 (March 1995), pp. 98–99.

Schmitz, Rudolf. "The Curbed Monumentality of the Invisible." *Parkett* (Zurich), no. 42 (Dec. 1994), pp. 100–01.

Searle, Adrian. "Rachel Doesn't Live Here Anymore." *Frieze* (London), no. 14 (Jan.–Feb. 1994), pp. 26–29.

Smith, Roberta. "The Best of Sculptors, the Worst of Sculptors." *The New York Times*, Nov. 30, 1993, pp. C15–16.

Storr, Robert. "The Struggle Between Forgetting and Remembering." *Artnews* (New York) 96, no. 3 (March 1997), pp. 127–28.

——. "Remains of the Day." *Art in America* (New York) 87, no. 4 (April 1999), pp. 104–09, 154.

Sylvester, David. "Carving Space." *Tate* (London), no. 17 (spring 1999), pp. 40–47.

Thistlewood, David J. "Reflections on the Demolition of House." *Contemporary Art* (Bath, U.K.) 2, no. 2 (spring 1994), pp. 7–9.

Usherwood, Paul. "The Rise and Rise of Rachel Whiteread." *Art Monthly* (London), no. 200 (Oct. 1996), pp. 11–13.

Von Drathen, Doris. "Rachel Whiteread: Found Form–Lost Object." *Parkett* (Zurich), no. 38 (winter 1993), pp. 22–31.

Wakefield, Neville. "Rachel Whiteread: Separation Anxiety and the Art of Release." *Parkett* (Zurich), no. 42 (Dec. 1994), pp. 76–89.

Watney, Simon. "About the House." *Parkett* (Zurich), no. 42 (Dec. 1994), pp. 104–11.

Young, James E. "Memory, Countermemory, and the End of the Monument." In Young, *At Memory's Edge: After-Images of the Holocaust in Contemporary Art and Architecture.* New Haven: Yale University Press, 2000, pp. 90–119.

Captions and photo credits
Cover, page 124, page 168 (detail): Rachel Whiteread, *Untitled (Basement),* 2001. Mixed media, 325 x 658 x 367 cm. Deutsche Guggenheim Berlin

Frontispiece: Rachel Whiteread, *Untitled (Apartment),* 2001. Mixed media, 285 x 1,109 x 614 cm. Deutsche Guggenheim Berlin

Page 63, left to right: Rio Grande River, New Mexico, 2000; Mt. Etna, Sicily, 2000; Taormina, Sicily, 2000; Cinque Terre, Italy. Page 64, top row, left to right: Concrete Buttress, Southern Ireland, 1996; Sunspot, New Mexico, 2000; Taormina, Sicily, 2000; Taormina, Sicily, 2000; Volcanic Eruption behind Ristorante 'Corsaro', Mt. Etna, Sicily; middle row, left to right: Taos, New Mexico, 2000; Luxor, Egypt, 1999; Luxor, Egypt, 1999; Cappadoccia, Turkey, 1999; Aeolian Islands, Sicily, 2000; bottom row, left to right: Cappadoccia, Turkey, 1999; Istanbul, 1999; Lipari Island, Aeolian Islands, Sicily, 2000; Kaufmann House (Falling Water), Bear Run, Pennsylvania, 1995. Page 65, top row, left to right: Greece, 1994; Istanbul, 1999; Llandovery, Wales, 1998; Luxor, Egypt, 1999; middle row, left to right: Millennium Wheel, London, 1999; Safranbolu, Turkey, 1999; Memphis, Egypt, 1999; bottom row, left to right: Hackney, London, 1997; Wales, 2000; Turkey, 1999. Page 66, top row, left to right: Quarry at Carrara, Italy, 1998; Cappadoccia, Turkey, 1999; bottom row, left to right: Caprese, Italy, 1998; Greece, 1993. Page 67, top row, left to right: Wonder Wheel, Coney Island, Brooklyn, New York, 1998; Severn Bridge, United Kingdom, 1998; bottom row, left to right: Venice, 1997; Taormina, Sicily, 2000; Wales, 2000. Page 68, top row, left to right: Carrara, Italy (photograph from postcard); Corinthian Dam, Greece, 1993; bottom row, left to right: Turkey, 1999; Hackney, London, 1996. Page 69, top row, left to right: Alamogordo, New Mexico, 2000; Turkey, 1999; Venice Arsenale, Venice, June 1999; middle row, left to right: Cide, Turkey, 1999; Hackney, London, 1996; bottom row, left to right: Berlin, 1992; Turkey, 1999. Page 70: Sachsenhausen, Oranienburg, Germany, 1992; Southern Ireland, 1996; bottom row, left to right: River Thames, London, 1998; Hackney, London, 1997.

All images of Rachel Whiteread's work courtesy of Anthony d'Offay Gallery unless otherwise indicated.
Covers and page 168: Mike Bruce; Pages 1–10, 14–30, 36, 39–46, 84, 87–132, 149–61: © Gautier Deblonde; Pages 11–13: Lisa Dennison; Page 33, right: Wolfgang Fuhrmannek © Artists Rights Society (ARS), New York / VG Bild-Kunst, Bonn; Page 35, right: David Heald; Page 36, left: Erika Ede Barahona © Artists Rights Society (ARS), New York, right: courtesy Virginia Dwan Gallery Archives; Page 51: Marcus Taylor; Page 56, left: courtesy Sperone Westwater Gallery, New York © Artists Rights Society (ARS), New York, right: courtesy Luhring Augustine Gallery, New York; Page 58: Werner Kaligofsky; Page 59: Photo © James P. Blair/CORBIS; Page 60: Marian Harders; Page 72: Sue Ormerod; Page 73, right: © Camilo José Vergara; Page 74: Saulo Bambi; Page 75, left: from Cynthia Davidson, ed., *Anybody,* Cambridge, Mass: MIT Press, 1997, p. 221, right: © Artists Rights Society (ARS), New York; Page 77 © 1960 (renewed 1988) by Condé Nast Publications, Inc.; Page 79: John Davies; Page 83: from Cynthia Davidson, ed., *Anybody,* Cambridge, Mass: MIT Press, 1997, p. 201; Page 138: Photo: Reuters New Media/CORBIS; Page 143, left: Prudence Cuming Associates, Ltd., right: Tate Gallery London/Art Resource, NY © VAGA, NY; Page 144, left: from Ludwig Wittgenstein, *Philosophical Investigations,* Oxford: Blackwell, 1997, p. 203, right: courtesy Tony Smith Estate © Artists Rights Society (ARS), New York; Page 145: from Ludwig Wittgenstein, *Philosophical Investigations,* Oxford: Blackwell, 1997, p. 203; Page 146, right: David Heald © Artists Rights Society (ARS), New York.

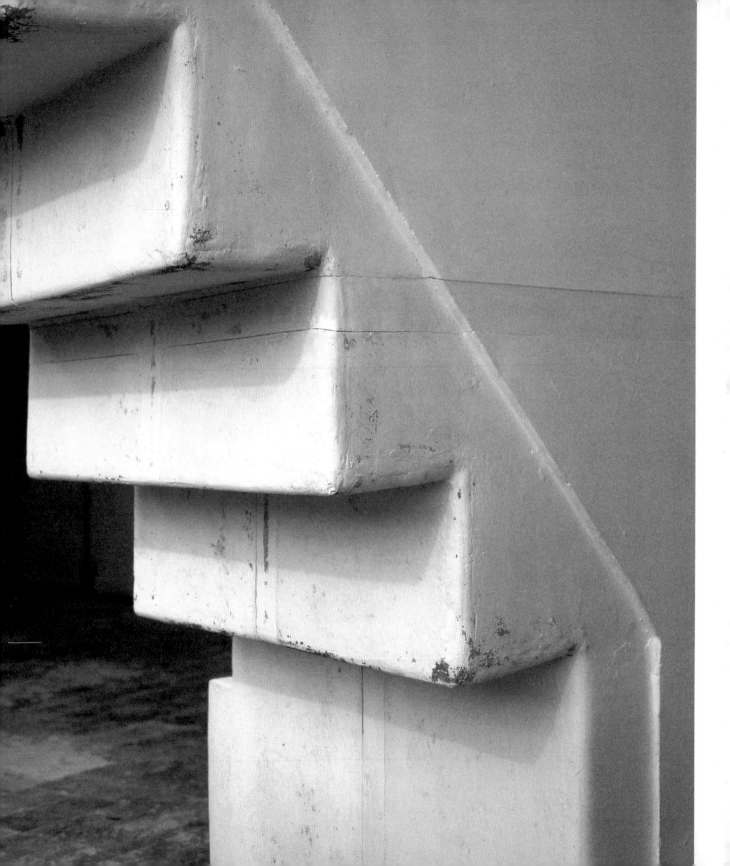